A Floral Affair

QUILTS & ACCESSORIES FOR ROMANTICS

Edited by Jennifer Rounds and Catherine Comyns

C&T PUBLISHING

© 2003 Nihon Vogue Co., Ltd

All text, illustrations and photographs selected from "Quilts Japan"

Originally published by Nihon Vogue Co., Ltd.

Copyright (c) 1998, 2000, 2001 by Nihon Vogue Co., Ltd.

All rights reserved

English translation rights arranged with Nihon Vogue Co Ltd., through Japan Foreign-Rights Centre.

Editor-in-Chief: Darra Williamson

Developmental Editor: Jennifer Rounds

Technical Editors: Catherine Comyns, Sharon Page Ritchie

Copyeditor/Proofreader: Joan Hyme, Linda D. Smith

Cover Designer: Kristen Yenche

Design Director/Book Designer: Kristen Yenche

Illustrator: Richard Sheppard

Production Assistant: Tim Manibusan

Photography: Norio Ando, Akinori Miyashita, Masaki Yamamoto, Chris Scott

Published by C&T Publishing, Inc., P.O. Box 1456, Lafayette, California, 94549

Front cover: *Cherry Blossom Quilt* (Page 28) by Hiroko Nakayama, Photo by Akinori Miyashita

Back cover: *Hexagon Cosmetic Bags* (Page 45) by Naoko Hashimoto, Photo by Norio Ando, *Wreath of Violets Quilt* (Page 34) by Chizuko Ono, Photo by Norio Ando, *Antique Rose Pineapple Quilt* (Page 6) by Naoko Uehara, Photo by Norio Ando

Attention Copy Shops: Please note the following exception—Publisher and author give permission to photocopy pages 15, 33, 38, 44, 48, 50, 56, 57, and 60 for personal use only.

Attention Teachers: C&T Publishing, Inc. encourages you to use this book as a text for teaching. Contact us at 800-284-1114 or www.ctpub.com for more information about the C&T Teachers Program.

We take great care to ensure that the information included in this book is accurate and presented in good faith, but no warranty is provided nor results guaranteed. Having no control over the choices of materials or procedures used, neither the author nor C&T Publishing, Inc. shall have any liability to any person or entity with respect to any loss or damage caused directly or indirectly by the information contained in this book. For your convenience, we post an up-to-date listing of corrections on our web page (www.ctpub.com). If a correction is not already noted, please contact our customer service department at ctinfo@ctpub.com or at P.O. Box 1456, Lafayette, California, 94549.

Trademarked (™) and Registered Trademark (®) names are used throughout this book. Rather than use the symbols with every occurrence of a trademark and registered trademark name, we are using the names only in the editorial fashion and to the benefit of the owner, with no intention of infringement.

Library of Congress Cataloging-in-Publication Data

A floral affair: quilts & accessories for romantics / edited by Jennifer Rounds & Catherine Comyns.

 p. cm.

Includes index.

 ISBN 1-57120-218-8

1. Patchwork--Patterns. 2. Quilting--Patterns. 3. Flowers in art. I. Rounds, Jennifer. II. Comyns, Catherine. III. Title.

TT835.F577 2003

746.46'041--dc21

 2003007610

Printed in China

10 9 8 7 6 5 4 3 2 1

ACKNOWLEDGEMENTS

To my fellow ballerinas and friends, Cariad Hayes Thronson and Hiroko Shibuya, thank you for your editorial and linguistic insights. (JR)

To Lynn Koolish and Joyce Lytle, our deepest thanks for your guidance and support.

To the amazing quiltermakers featured in this book, your quilts are wonderful!

Contents

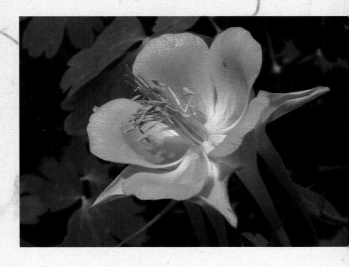

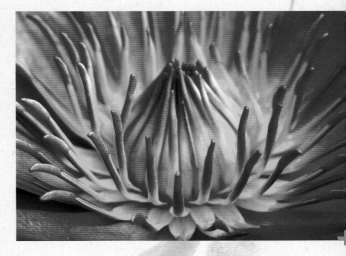

Introduction

In *A Bouquet of Quilts* we explored a garden full of traditional quilting projects from Nihon Vogue's beautiful magazine, *Quilts Japan*. With *A Floral Affair* we take a look at sweeter, more tender, and romantic projects from Nihon Vogue.

Why do we turn to *Quilts Japan* as a project resource? Simply because every issue of Nihon Vogue's magazine *Quilts Japan* is a visual delight well worth sharing with our quilting friends who don't have easy access to the magazine. The work of these Japanese quiltmakers is remarkable, transcendent, and awe-inspiring—each turn of the page evokes a gasp of amazement or sigh of pleasure. The women speak a dialect of quilting that everyone can understand and appreciate. It's our pleasure at C&T Publishing to bring you another glimpse of the craftsmanship of our Japanese quilting neighbors.

We are all susceptible to romance. Candlelit dinners, kisses in the moonlight, whispered endearments, and hearts and flowers evoke our tenderest feelings. What better way to celebrate a romance or remember a special moment or person than to make a pretty quilt or decorative memento? The projects we explore include:

Antique Rose Pineapple Quilt: A lovely antique rose fabric and a simple grid of pineapple blocks with two-tone accents create a quilted "affair to remember."

Flower Storm Quilt: You've heard of a whirlwind romance? Here's a quilt that captures that feeling with a swirling tempest of flower petals.

Campo di Flori Quilt: An ideal project for the floral fabric collector, this quilt has a serene, atonal palette of colors that captures a European flavor—why not succumb to a "foreign affair"?

Campo di Flori Pillows: Smaller scale projects that use our beloved florals, including one pillow with an unusual two-color interwoven lattice.

Cherry Blossom Quilt: This remarkable quilt evokes Love's special season. The unique touch of three-dimensional flowers elevates this quilt from sweetly pretty to extraordinary.

Wreath of Violets Quilt: This quilt recreates the charm of a nosegay of deep purple violets—harbingers of spring, violets symbolize constancy in the language of flowers.

Blossom Pillow: A spin on pillow décor that creates a fancy new party dress for a "wallflower" pillow.

Hexagon Garden Accessories—Cosmetic Bag, Travel Kit, and Purse: Honeymoon or romantic getaway on the horizon? Here's a pretty assortment of travel bags for a newlywed bride or a traveling sweetie.

Hexagon Garden Quilt: This project evokes wedded bliss with a harmonious progression of colors from the earth to the sky with vivid blossoms in between.

As in *A Bouquet of Quilts,* we offer project specifications in both standard U.S. and metric measurements and easy-to-use charts for simplified fabric selection and cutting. In addition, we include projects suitable for a variety of skill levels and incorporating a wide range of techniques. This time around we also extend beyond the two-dimensional plane with wonderful three-dimensional floral projects and entrancing accessories.

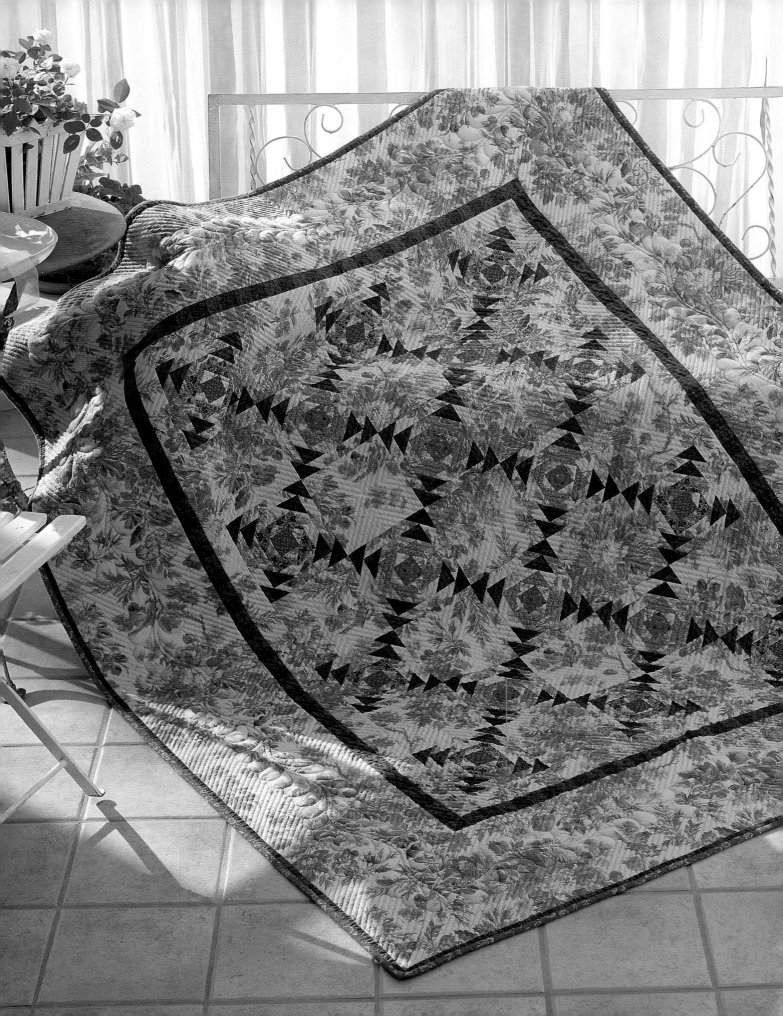

Antique Rose Pineapple Quilt

Finding a project suitable for showcasing large-scale prints is always a challenge. This pattern is ideal for the task because the pineapple squares float on the floral field, enhancing the impact of a large-scale print. The pictured quilt uses an antique climbing rose fabric and a simple two-color contrasting accent.

FABRIC REQUIREMENTS

U.S.		Metric
4 yards	Large-scale floral for the alternate squares, triangles, rectangles, first, and third borders	3.7 meters
1 yard	Red print for the pieced blocks and the binding	80 cm
1 yard	Dark green for the pieced blocks, second, and fourth borders	80 cm
3⅞ yards	Backing	3.4 meters
56" x 68"	Batting	140 cm x 170 cm

CUTTING

U.S.	Large floral	Metric
6½" x 6½"	Alternate squares: Cut 17.	15.2 cm x 15.2 cm
2" x 2"	B: Cut 36. Cut each square in half diagonally to make 72 triangles.	4.7 cm x 4.7 cm
1¼" x 3½"	D1: Cut 36.	3 cm x 8.2 cm
1¼" x 5"	D2 and F1: Cut 72 total.	3 cm x 11.7 cm
1¼" x 6½"	F2: Cut 36.	3 cm x 15.2 cm
2" x 58"	First top and bottom borders: Cut 2.	4.7 cm x 145 cm
2" x 70"	First side borders: Cut 2.	4.7 cm x 175 cm
8" x 58"	Third top and bottom borders: Cut 2.	23.2 cm x 145 cm
8" x 70"	Third side borders: Cut 2.	23.2 cm x 175 cm

Made by Naoko Uehara, Photo by Norio Ando
Finished Quilt Size: 52" x 64" (130 cm x 158 cm)
Finished Block Size: 6" x 6" (14 cm x 14 cm)
Techniques: Piecing

U.S.	Red print	Metric
2" x 2"	A: Cut 18.	4.7 cm x 4.7 cm
2⅜" x 2⅜"	C: Cut 36. Cut each square in half to make 72 triangles.	5.7 cm x 5.7 cm
3" x 238"	Binding is double-folded, cut on the straight of grain.	7.5 cm x 610 cm

U.S.	Dark green	Metric
2" x 2"	E: Cut 144.	5 cm x 5 cm
1⅝" x 58"	Second top and bottom borders: Cut 2.	3.9 cm x 145 cm
1⅝" x 70"	Second side borders: Cut 2.	3.9 cm x 175 cm
1⅛" x 58"	Fourth top and bottom borders: Cut 2.	2 cm x 145 cm
1⅛" x 70"	Fourth side borders: Cut 2.	2 cm x 175 cm

BLOCK ASSEMBLY

1. Sew a B triangle to the top and bottom of each A square. Press the seams toward the B triangles. Sew a B triangle to the 2 remaining sides of each A square. Press the seams toward the B triangles. Make 18 AB units.

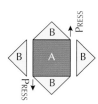

Make 18 AB units

2. Sew a C triangle to the top and bottom of each AB unit. Press the seams toward the C triangles. Sew a C triangle to the 2 remaining sides of each AB unit. Press the seams toward the C triangles.

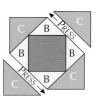

3. Sew a D1 strip to the top and bottom of each unit made in Step 2. Press the seams toward the D1 strips. Sew a D2 strip to the 2 remaining sides of each unit. Press the seams toward the D2 strips.

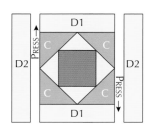

4. Draw a diagonal line on the back of each E square, from corner to corner. Right sides together, place an E square on each outside corner of the block. Sew along the marked lines. Trim ¼" (0.6 cm) from the sewn lines.

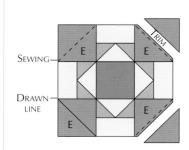

Trim leaving ¼" (0.6 cm) seam allowance

Press the seams toward the resulting E triangles.

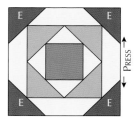

5. Sew F1 strips to the top and bottom of the unit made above. Press the seams toward the F1 strips. Sew F2 strips to the 2 remaining sides of each pieced unit. Press the seams toward the F2 strips.

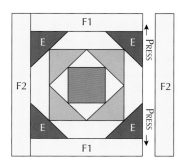

6. Add E squares to each corner of the pieced units following the procedure in Step 4.

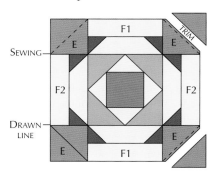

QUILT ASSEMBLY

1. Make 4 rows of 3 pieced blocks alternating with 2 floral squares. Press the seams toward the floral squares.

2. Make 3 rows of 3 floral squares alternating with 2 pieced blocks. Press the seams toward the floral squares.

3. Sew the quilt top together by alternating the rows made in Step 1 with the rows made in Step 2. Press the quilt top.

BORDERS

Sew together all the border strips before attaching them to the quilt top. Refer to General Instructions on page 61 for applying a mitered border.

FINISHING

Layer and baste the backing, batting, and quilt top. Quilt a diagonal grid across the center of the quilt. Quilt the inner green border with a small cable design. Quilt the large floral border with a large cable design, then add a diagonal grid to the background of the border.

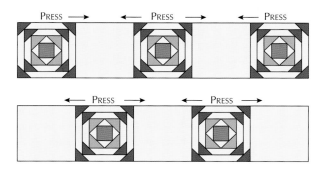

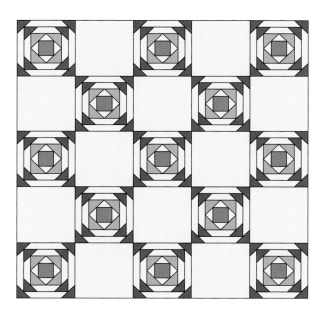

Quilt Assembly

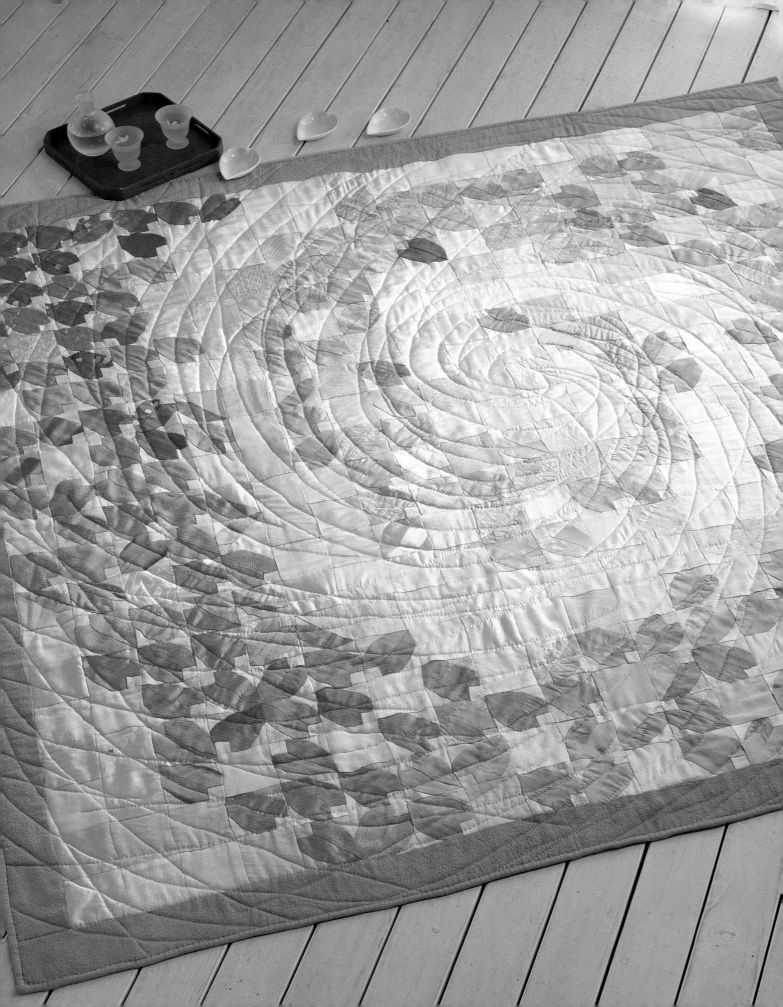

Flower Storm Quilt

When our translator Hiroko Shibuya showed us the name of this quilt we were enchanted by its aptness. These days newlyweds are greeted with showers of rose petals instead of rice, creating a wonderful and fragrant celebration of a very special day. Note: Use of a design wall is highly recommended.

FABRIC REQUIREMENTS

U.S.		Metric
4 yards	Assorted solid cream, beige, and pale pink for plain squares and background of petal blocks	3.3 meters
2½ yards	Assorted light to dark pink for petals	2.3 meters
1¼ yards	Light green for border and binding	1 meter
3⅝ yards	Backing	3.4 meters
66" x 66"	Batting	1.7 meters x 1.7 meters

CUTTING

U.S.	Background: Solid cream, beige, and pale pink	Metric
3¼" x 3¼"	Plain squares: Cut 175.	8.2 cm x 8.2 cm
3⅝" x 3⅝"	Half-petal blocks: Cut 4. Cut each square in half diagonally to make 8 triangles.	9.2 cm x 9.2 cm
1⅝" x 1⅝"	Half-corner of half-petal blocks: Cut 4. Cut each square in half diagonally for a total of 8.	4.1 cm x 4.1 cm
	Cut 223 B. Mark dots.	
	Cut 219 Br. Mark dots.	
1¼" x 1¼"	Corner square A of petal blocks: Cut 217.	3.1 cm x 3.1 cm

Made by Yoko Kanakubo, Photo by Akinori Miyashita
Finished Size: 61¼" x 61¼" (155.6 cm x 155.6 cm)
Finished Block Size: 2¾" x 2¾" (7 cm x 7 cm)
Techniques: Curved piecing/Y-seams

U.S.	Petals: Light to dark pink	Metric
	Cut 223 C. Mark dots.	
	Cut 219 Cr. Mark dots.	

U.S.	Borders: Light green	Metric
3⅜" x 55½"	Side borders: Cut 2.	8.4 cm x 141.2 cm
3⅜" x 61¼"	Top and bottom borders: Cut 2.	8.4 cm x 155.6 cm
2¼" x 260"	Binding	4.8 cm x 660 cm

Note: *The quilt has 3 types of pieced blocks: 217 complete petal blocks, 6 left half-petal blocks, and 2 right half-petal blocks.*

LEFT HALF-PETAL BLOCK ASSEMBLY

1. For each block choose a B, a small triangle, and a large triangle all of the same background fabric. Sew a B to a C, matching the dots and with B on top as you sew. Press the seam toward the petal.

2. Sew the small triangle to the straight edge of C. Press the seam toward the petal.

3. Sew a large triangle to the half-petal unit. Press the seam toward the large triangle. Make 6 blocks.

Left half-petal block
Make 6

RIGHT HALF-PETAL BLOCK ASSEMBLY

1. Choose a Br, a small triangle, and a large triangle all of the same background fabric. Sew a Br to a Cr, matching the dots and with Br on top as you sew. Press the seam toward the petal.

2. Sew a small triangle to the straight edge of Cr. Press the seam toward the petal.

3. Sew a large triangle to the half-petal unit. Press the seam toward the large triangle. Make 2 blocks.

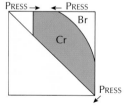

Right half-petal block
Make 2

PETAL BLOCK ASSEMBLY

1. Choose a corner square A, B, and Br all of the same background fabric. Choose a C and Cr of a petal fabric.

2. Sew the curved edge of B to the curved edge of C, matching the dots with B on top as you sew. Press the seam toward the petal.

3. Sew the curved edge of Br to the curved edge of Cr, matching the dots with Br on top as you sew. Press the seam toward the petal.

4. Sew 1 side of the corner square A to the straight edge of the petal, from the outside edge of the block. Stop sewing ¼" (0.6 cm) from the inside edge of the corner square.

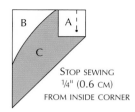

STOP SEWING ¼" (0.6 CM) FROM INSIDE CORNER

5. Sew the straight edge of Cr to the bottom edge of the corner square A, from the outside to ¼" (0.6 cm) from the inside edge.

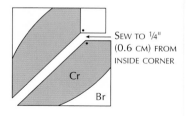

SEW TO ¼" (0.6 CM) FROM INSIDE CORNER

Sewing straight edge of Cr

6. Sew C to Cr, keeping the point of the corner square out of the way.

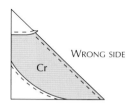

WRONG SIDE

Stitch C to Cr

7. Press the petal seam open and then press the corner square seams over the open petal seam. Make 217 blocks.

PRESS OPEN C/CR SEAM

Pressing the block

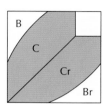

Make 217

QUILT ASSEMBLY

1. Place the petal blocks and the plain squares in a swirling arrangement. See the Quilt Assembly diagram on page 14.

2. Sew the blocks into 20 rows of 20 blocks each. Press the seams of the rows in alternating directions. Sew the rows together to make the quilt top. Press carefully.

BORDERS

1. Measure the quilt top lengthwise through the center, and trim the 2 side borders to this length. Sew the 2 side borders to the quilt top. Press seams toward the borders.

2. Measure the quilt width through the center, including the side borders, and trim the top and bottom borders to this length. Sew top and bottom borders to the quilt top. Press seams toward the borders.

FINISHING

Layer and baste the backing, batting, and quilt top. Quilt in a swirling design that starts in the center of the quilt and extends to the borders.

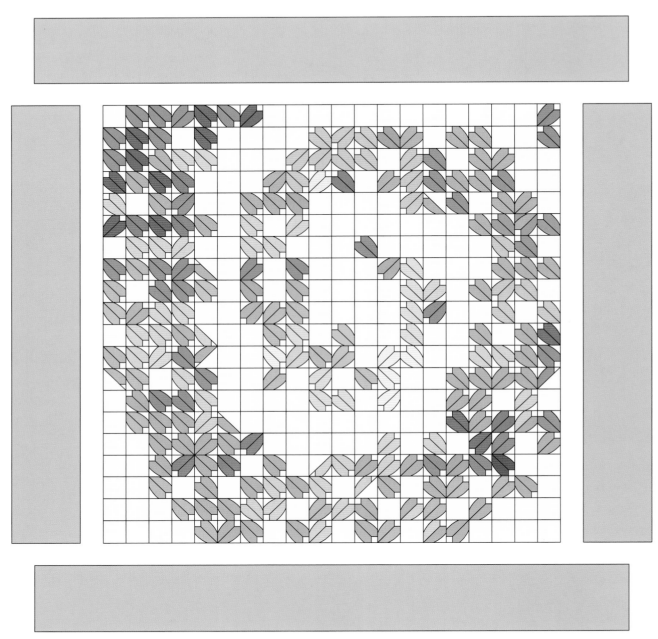

Quilt Assembly

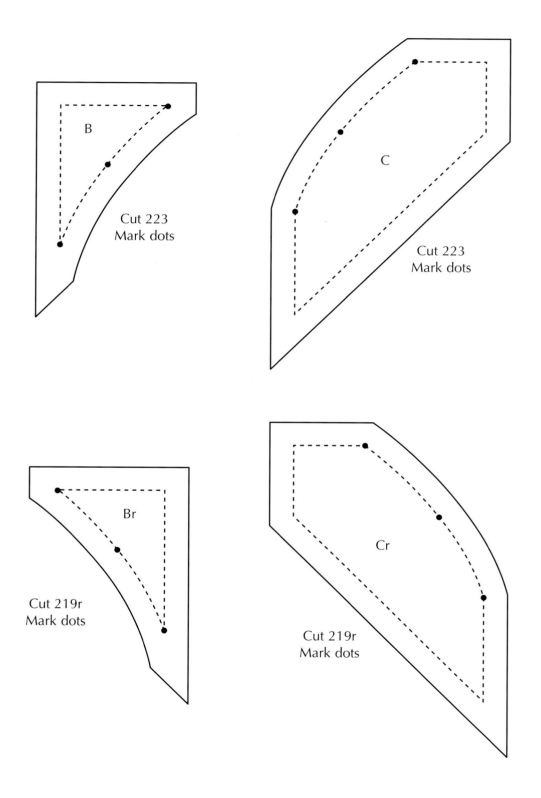

B

Cut 223
Mark dots

C

Cut 223
Mark dots

Br

Cut 219r
Mark dots

Cr

Cut 219r
Mark dots

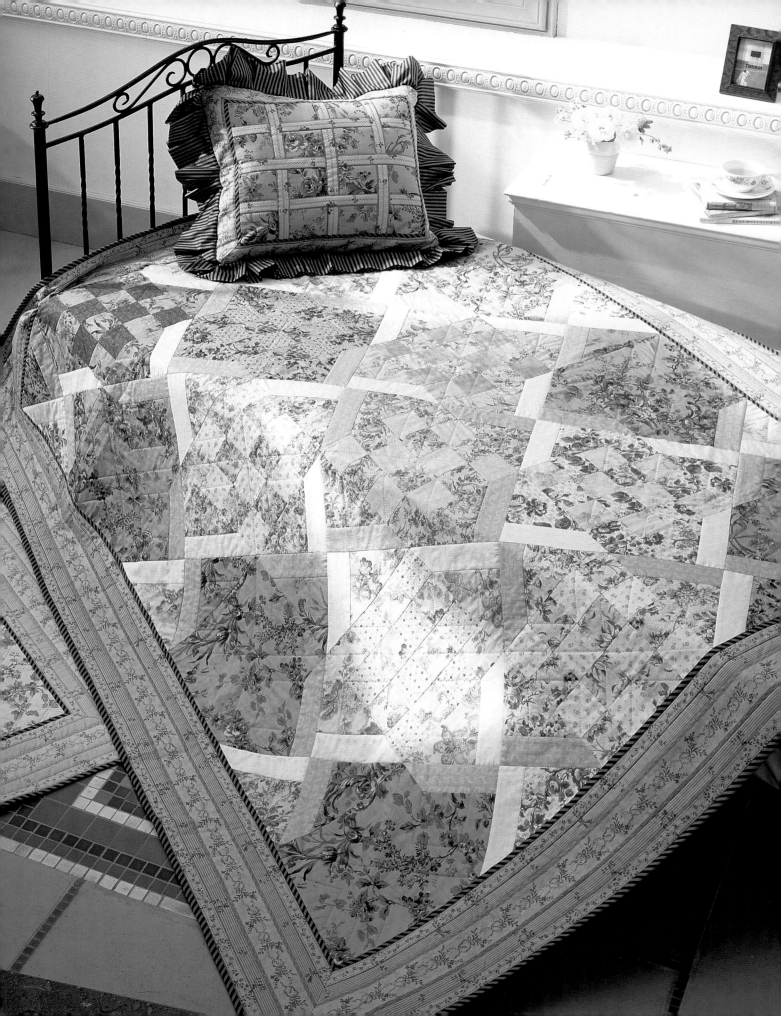

Campo di Flori Quilt

Campo di Flori *means field of flowers in Italian. This quilt has a European flair with its subtle color tones, sophisticated placement of floral prints, and unique silvery white pinwheel accents. Have you been looking for a great pattern to use your floral stash?* Campo di Flori *is the perfect project for the flower-crazed quilter. If you want to add a dash of fun to your decorative scheme, make the* Campo di Flori *pillow projects on page 22 and 26. Note: Use of a design wall is highly recommended.*

FABRIC REQUIREMENTS

U.S.		Metric
1½ yards	Large-scale floral for large squares and Windmill blocks	1 meter
⅜ yard each	9 assorted medium-scale florals for Windmill blocks and 16-Patch blocks	30 cm each
⅛ yard each or ⅞ yard of 1 fabric	9 assorted small-scale non-floral or small geometric prints for 16-Patch blocks	10 cm each or 60 cm of 1 fabric
⅞ yard	Light tone-on-tone for Windmill blocks	60 cm
⅞ yard	Medium tone-on-tone for Windmill blocks	60 cm
1⅜ yard	Diagonally printed stripe for first border and binding	1.1 meters
2½ yard	Striped floral for second border	2.1 meters
5 yards	Backing	4.2 meters
79" x 91"	Batting	1.9 meters x 2.2 meters

Made by Mariko Akizuki, Photo by Akinori Myashita
Finished Size: 75" x 87" (177 cm x 205 cm)
Finished Block Size: 12" x 12" (28 cm x 28 cm)
Techniques: Piecing

U.S.	Large-scale floral	Metric
12½" x 12½"	Large squares: Cut 6.	29.2 cm x 29.2 cm
10¼" x 10¼"	Windmill blocks: Cut 4. Cut each square diagonally into quarters for a total of 16 triangles.	24.2 cm x 24.2 cm

U.S.	Medium-scale floral	Metric
3½" x 3½"	16-Patch blocks: Cut 8 from each fabric to total 72 squares.	8.2 cm x 8.2 cm
10¼" x 10¼"	Windmill blocks: Cut 1 to 2 squares from each of the medium-scale florals to total 11 squares. Cut diagonally into quarters for a total of 44 triangles.	24.2 cm x 24.2 cm

U.S.	Small-scale print	Metric
3½" x 3½"	16-Patch blocks: Cut 8 from each fabric to total 72 squares.	8.2 cm x 8.2 cm

U.S.	Light tone-on-tone	Metric
2⅝" x 10½"	Cut 30 rectangles. *Note: This measurement is slightly larger than needed.*	6.2 cm x 25 cm

U.S.	Medium tone-on-tone	Metric
2⅝" x 10½"	Cut 30 rectangles. *Note: This measurement is slightly larger than needed.*	6.2 cm x 25 cm

U.S.	Diagonally printed stripe	Metric
1" x 75"	First top and bottom borders: Cut 2.	2.2 cm x 177 cm
1" x 87"	First side borders: Cut 2.	2.2 cm x 205 cm
3¾" x 336"	Binding	9 cm x 795 cm

U.S.	Striped floral	Metric
7¼" x 75"	Second top and bottom borders: Cut 2.	18.1 cm x 177 cm
7¼" x 87"	Second side borders: Cut 2.	18.1 cm x 205 cm

16-PATCH BLOCK ASSEMBLY

1. Choose a floral fabric and a small-scale print or geometric fabric for each block. Sew 4 squares together to make a row, alternating floral with print squares. Make 4 rows. Press the seams toward the floral squares. Sew the 4 rows together to make each block. Press. Make 9 blocks.

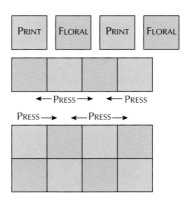

Assembling a 16-Patch block
Make 9

2. Arrange the large floral squares and the 16-Patch blocks in a pleasing manner on a design wall, leaving space for the alternating Windmill blocks.

WINDMILL BLOCK ASSEMBLY

Important: Refer to the Quilt Assembly diagram when constructing the Windmill blocks. There is a specific pattern to follow. Each floral triangle of a Windmill block matches a floral 16-Patch block or large floral square next to it and the windmill paddles turn from row to row. Note also on the Quilt Assembly diagram that the remaining floral triangles are placed randomly as the outermost triangles of the Windmill blocks that edge the quilt top.

1. Choose and arrange 4 floral fabric triangles so that each one will match the neighboring 16-Patch block or large floral square.

2. Sew a light tone-on-tone strip to 2 floral triangles and a medium tone-on-tone strip to the other 2 floral triangles. When sewing a strip to a triangle, line up one end of the strip with the top point of the triangle and then sew toward the base of the triangle. The strip will be longer than the side of the triangle. Press the seam toward the tone-on-tone strip. Trim the end of the strip even with the base of the triangle.

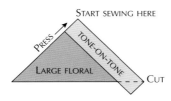

Assembling a Windmill
Make 30 medium tone-on-tone
Make 30 light tone-on-tone

3. Sew the 4 triangle units together to make a Windmill block. Make 15 blocks.

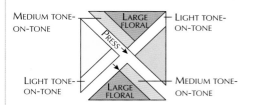

Assembling a Windmill block
Make 15

4. Place each block in position on the design wall and verify its correct placement.

QUILT ASSEMBLY

Sew the rows together horizontally following the Quilt Assembly diagram.

BORDERS

Sew together the first and second border strips before attaching them to the quilt top. Refer to General Instructions on page 61 for mitered borders.

FINISHING

Layer and baste the backing, batting, and quilt top. Quilt a diagonal grid across the center of the quilt. Quilt the border in parallel lines that run the length of the border strips.

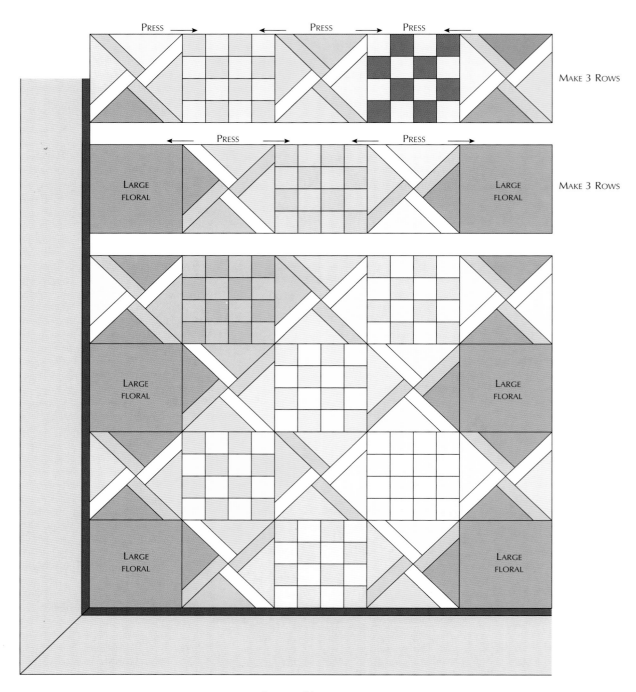

Quilt Assembly

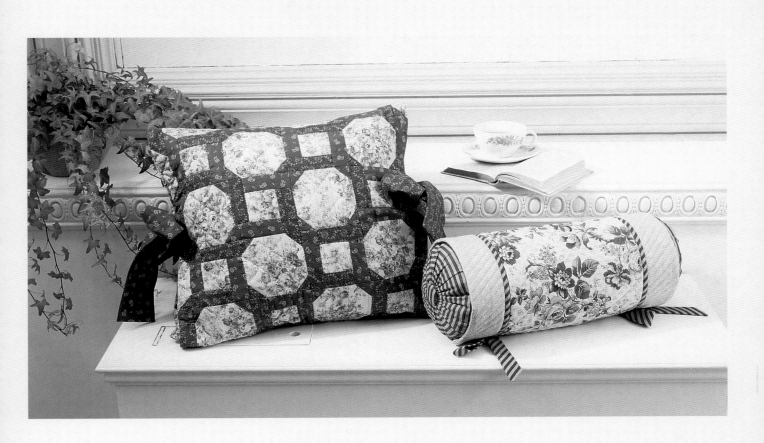

Campo di Flori Pillows

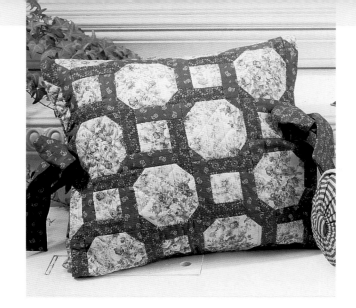

This decorator pillow is a pretty and unusual spin on typical pillow fare with two-color interlocking links that frame a floral print. What a clever way to show off a favorite floral fabric!

Campo di Flori Pillow

FABRIC REQUIREMENTS

U.S.		Metric
1½ yards	Floral for blocks, setting units, and lining	1.3 meters
¾ yard	Dark tone-on-tone A for blocks, setting units, and ties	65 cm
¾ yard	Medium tone-on-tone B for blocks, setting units, and ties	65 cm
22" x 40"	Batting	55 cm x 1 meter
18" x 18"	Pillow form	45 cm x 45 cm
2¾ yards	1½" (3.7 cm) single-fold bias tape to match pillow lining	2.5 meters

Made by Mariko Akizuki, Photo by Akinori Myashita
Finished Size: 18" x 18" (45 cm x 45 cm)
Finished Block Size: 4" x 4" (10 cm x 10 cm)
Techniques: Piecing

CUTTING

U.S.	Floral	Metric
4½" x 4½"	Snowball block: Cut 18 squares.	11.2 cm x 11.2 cm
2½" x 2½"	Log Cabin block: Cut 18 squares.	6.2 cm x 6.2 cm
1½" x 4½"	Setting Unit 3: Cut 9 rectangles.	3.7 cm x 11.2 cm
22" x 40"	Lining (pillow backing that will not be seen) Cut 2.	55 cm x 1 meter

U.S.	Dark tone-on-tone A	Metric
1½" x 1½"	Snowball blocks, Setting Units 2 and 3: Cut 44 squares.	3.7 cm x 3.7 cm
1½" x 3½"	Log Cabin blocks, Setting Unit 1: Cut 41 rectangles.	3.7 cm x 8.7 cm
6" x 21½"	Side ties: Cut 2 rectangles.	15.2 cm x 55.2 cm

U.S.	Medium tone-on-tone B	Metric
1½" x 1½"	Snowball blocks, Setting Units 1 and 3: Cut 55 squares.	3.7 cm x 3.7 cm
1½" x 3½"	Log Cabin blocks, Setting Unit 2: Cut 40 rectangles.	3.7 cm x 8.7 cm
6" x 21½"	Side ties: Cut 2 rectangles.	15.2 cm x 55.2 cm

SNOWBALL BLOCK ASSEMBLY

For each block you will need a floral 4½" x 4½" (11.2 cm x 11.2 cm) square and either 4 dark or 4 medium tone-on-tone 1½" x 1½" (3.7 cm x 3.7 cm) squares.

1. With right sides together, place a tone-on-tone square onto each corner of a floral square. Sew diagonally across the tone-on-tone squares.

2. Trim the corners, ¼" (0.6 cm) from the stitching line. Press the resulting tone-on-tone corner triangles away from the floral block centers. Make 8 Snowball blocks with dark tone-on-tone corners and 10 Snowball blocks with medium tone-on-tone corners.

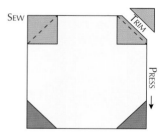

Constructing a Snowball block
A Blocks: 8 dark tone-on-tone
B Blocks: 10 medium tone-on-tone

LOG CABIN BLOCK ASSEMBLY

For each block you will need a floral 2½" x 2½" (6.2 cm x 6.2 cm) square and 2 dark tone-on-tone and 2 medium tone-on-tone 1½" x 3½" (3.7 cm x 8.7 cm) rectangles.

Note: This block builds in typical Log Cabin block fashion except the first seam is partially sewn to the center square and then finished after the fourth strip is sewn in place. Remember to press the seams toward the logs as you sew.

1. Following the illustration, sew a medium tone-on-tone rectangle to 1 side of the floral square, starting at the top corner of the square. Sew 1¼" (3 cm) down the side and stop. Finger press toward the rectangle.

2. Sew a dark tone-on-tone rectangle to the next side of the floral square and rectangle as shown. Press.

3. Sew a second medium tone-on-tone rectangle to the next side of the block. Press.

4. Sew a second dark tone-on-tone rectangle to the block. Press.

5. Now complete the first seam. Press. Make 18 blocks.

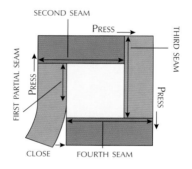

Constructing a Log Cabin block
Make 18

SETTING UNIT 1

For each unit you will need an A rectangle and a B square. Right sides together, sew the square to the rectangle. Press the seam toward the rectangle. Make 5 units.

Constructing Setting Unit 1
Make 5

SETTING UNIT 2

For each unit you will need a B rectangle and an A square. Right sides together, sew the square to the rectangle. Press the seam toward the rectangle. Make 4 units.

Constructing Setting Unit 2
Make 4

SETTING UNIT 3

For each unit you will need a floral 1½" x 4½" (3.7 cm x 11.2 cm) rectangle and either 2 A or 2 B squares.

Right sides together, place a tone-on-tone square onto each end of a floral rectangle. Sew diagonally across the tone-on-tone squares. Trim ¼" (0.6 cm) from the stitching lines. Press corner triangles away from the floral rectangles. Make 4 units with dark tone-on-tone corners and 5 units with medium tone-on-tone corners.

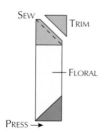

Constructing Setting Unit 3
Make 4 A's
Make 5 B's

ASSEMBLY

1. Each row has 4 alternating blocks of Snowballs and Log Cabins. Make 5 rows with a Log Cabin/Snowball pattern and 4 rows with a Snowball/Log Cabin pattern. Press toward the Log Cabins.

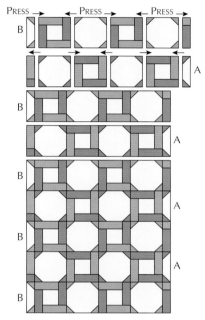

Pillow Top Assembly

2. Add a Setting Unit 3 with medium tone-on-tone triangles and a Setting Unit 1 to each end of the 5 Log Cabin/Snowball rows. Press as shown.

3. Add a Setting Unit 3 with dark tone-on-tone triangles and a Setting Unit 2 to each end of the 4 Snowball/Log Cabin rows. Press as shown.

4. Assemble the pillow top by alternating the 2 different rows. Press.

FINISHING

1. Layer and baste the batting, lining, and pillow top.

2. Quilt a diagonal grid across the pillow top.

3. Trim the batting and lining edges even with the pillow edges.

4. Right sides together, fold the pillow top in half and sew the short ends together using a ¼" (0.6 cm) seam allowance.

5. Trim the batting from the seam. Press the seam open.

FACINGS

1. Cut an 18½" (46.2 cm) length of single-fold bias tape and hand stitch in place to cover the raw seam.

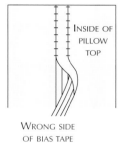

Covering the inside seam

2. To bind the side raw edges, cut 2 36½" (91.3 cm) lengths of single-fold bias tape and, right sides together, sew the short ends using a ¼" (0.6 cm) seam allowance. Press the seams open. Pin 1 side of the bias tape facing to the raw edges of the right side of the pillow top and sew. Repeat for the other end.

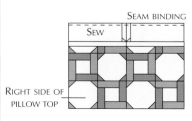

Applying the side facing

3. Press the facings to the inside of the pillow top and hand stitch in place to the lining. Be careful not to let your stitching show through to the front of the pillow top.

TIES

1. Fold the ties in half lengthwise, right sides together. Sew along the long side and 1 short end of each tie. Trim the corners and turn the ties right side out. Press.

2. Turn the pillow top to the lining side. Pin a pair of ties to the midpoints of each opening. Make sure to line up the raw ends of the ties with the inside edges of the seam binding.

3. Fold up the ties to cover their raw edges and stitch in place as shown.

Stitching side facings and ties

4. Insert the pillow form and tie the sides closed.

Neck roll pillows are a special treat, especially dressed up in pretty floral prints.

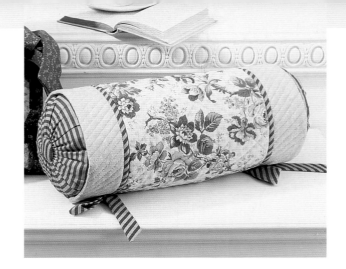

Campo di Flori
Neck Roll Pillow

FABRIC REQUIREMENTS

U.S.		Metric
⅜ yard	Floral print	30 cm
⅜ yard	Gray solid	25 cm
¾ yard	Stripe	70 cm
⅝ yard	Backing	55 cm
⅝ yard	Lining	50 cm
20" x 26"	Batting	50 cm x 65 cm
2	1½" (3.8 cm) buttons to cover	2
7½" x 18"	Neck roll pillow form	19 cm x 45 cm

CUTTING

U.S.	Floral print	Metric
10½" x 25½"	Cut 1.	26.2 cm x 63 cm

U.S.	Gray solid	Metric
4" x 25½"	Cut 2.	10 cm x 63 cm

Made by Mariko Akizuki, Photo by Akinori Myashita
Finished Size: 7½" x 18" (19 cm x 45 cm)
Techniques: Piecing

U.S.	Stripe	Metric
5" x 24½"	Ends: Cut 2 with the stripes running lengthwise.	12.7 cm x 61.2 cm
1" x 25½"	Narrow borders: Cut 2 on the bias.	2.4 cm x 63 cm
3" x 12½"	Ties: Cut 4 on the bias.	7.5 cm x 32 cm

U.S.	Backing	Metric
20" x 26"	Cut 1.	50 cm x 65 cm

U.S.	Lining	Metric
18½" x 24½"	Cut 1.	46.2 cm x 61.2 cm

ASSEMBLY

1. Piece the pillow cover as shown.

24½" (61.2 CM)

18½" (46.2 CM)

Pillow Cover Assembly

2. Layer the backing, batting, and pillow. Baste. Quilt a cross-hatched pattern on the floral fabric and diagonal lines in the side areas. Trim as shown.

3. Fold the ties right sides together and sew along the long sides. Trim 1 end of each tie at a 45° degree angle. Sew the angled end and trim.

TRIM

Sewing the ties

4. Turn each tie right side out and press. Pin and baste each tie to the right side of the pillow cover at the narrow border.

5. Turn the short sides of the end pieces to the wrong side ¼" (0.6 cm). Press and baste.

6. Right sides together, pin and baste the length of the end pieces to the long sides of the pillow cover. The end pieces should be ¼" (0.6 cm) from each end of the pillow cover.

Placement of end pieces

7. Right sides together, pin and sew the lining to the pillow cover, leaving an opening for turning.

Sewing the lining

8. Turn the pillow cover right side out and press. Use whipstitches to close the opening.

9. Fold the pillow top, wrong sides together, and whipstitch the basted ends closed.

10. Sew 2 rows of basting stitches along each end piece. Pull the basting stitches tight to gather the ends. Stitch to secure.

Finishing the pillow cover

11. Cover buttons with striped fabric following the package directions. Stitch the buttons in place at each gathered end. Insert the pillow form and tie the ends to close the pillow cover.

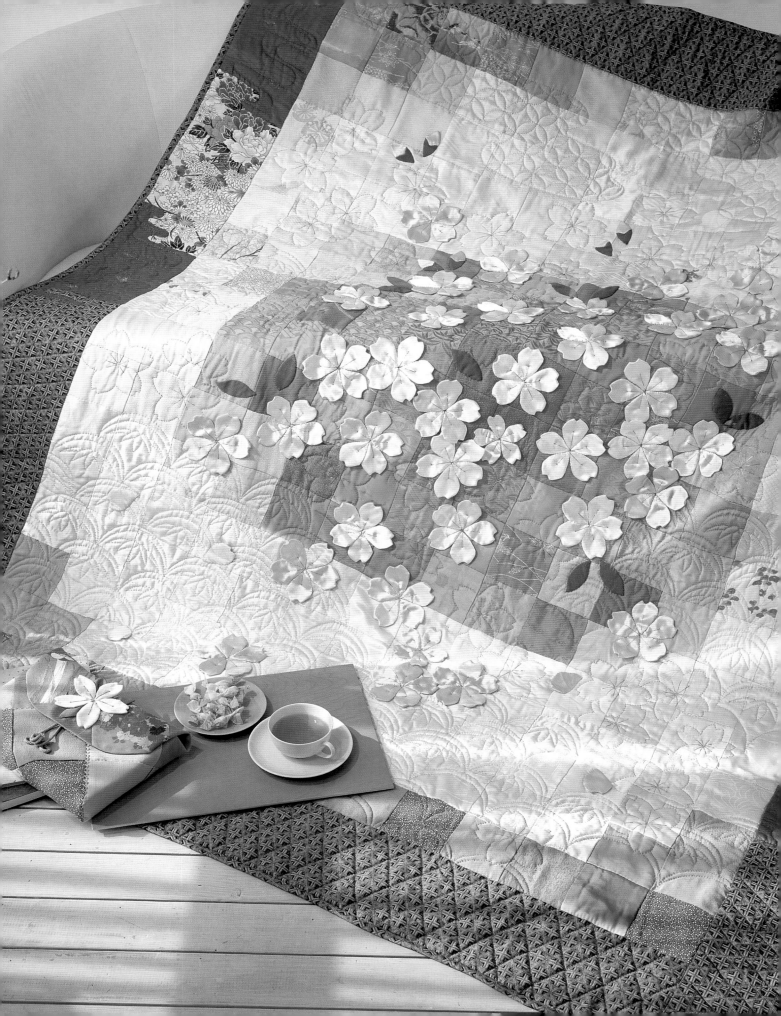

Cherry Blossom Quilt

In Japan, the blossoming cherry tree is the quintessential symbol of springtime and springtime everywhere is the season for romance. To create the most authentic version of this quilt use silk fabric for the petals and leaves and gold thread for the flower stamens. For those looking for a more practical alternative to silk, RJR Fashion Fabrics offers Quilter's Sateen, a nice line of solids with a silk-like sheen. Note: Use a design wall to lay out the quilt before sewing.

FABRIC REQUIREMENTS

U.S.		Metric
1⅛ yards	Assorted pinks, corals, and oranges for background squares	1.1 meters
½ yard	Assorted blues, grays, and lavenders for background squares	45 cm
½ yard	Assorted greens, grays, and beiges for background squares	45 cm
1½ yards	Assorted creams, beiges, and pinks for background squares	1.6 meters
2 yards	Assorted pale pinks for petals and buds	1.9 meters
¼ yard	Green for leaves and calyx	15 cm
2⅛ yards	Brown geometric for border and binding	2 meters
⅜ yard	Floral for border	35 cm
½ yard	Dark solid for border	50 cm
4½ yards	Backing	4.1 meters
66" x 80"	Batting	170 cm x 205 cm
	Embroidery floss	
	Stiletto for turning small sewn petals and leaves	

Made by Hiroko Nakayama, Photo by Akinori Miyashita
Finished Size: 61½" x 75½" (157.4 cm x 193.4 cm)
Finished Block Size: 3½" x 3½" (9 cm x 9 cm)
Techniques: 3-D Appliqué

CUTTING

U.S.	Assorted pinks, corals, and oranges	Metric
4" x 4"	Background squares: Cut 80.	10.2 cm x 10.2 cm

U.S.	Assorted blues, grays, and lavenders	Metric
4" x 4"	Background squares: Cut 26.	10.2 cm x 10.2 cm

U.S.	Assorted greens, grays, and beiges	Metric
4" x 4"	Background squares: Cut 26.	10.2 cm x 10.2 cm

U.S.	Assorted creams, beiges, and pinks	Metric
4" x 4"	Background squares: Cut 120.	10.2 cm x 10.2 cm

U.S.	Assorted pale pinks	Metric
♡	Petals: Cut 410.	♡
◊	Buds: Cut 14.	◊

U.S.	Green	Metric
◊	Leaves: Cut 15.	◊
♡	Calyx: Cut 7.	♡

U.S.	Brown geometric	Metric
6½" x 49½"	Top and bottom borders: Cut 2.	16.3 cm x 127.2 cm
6½" x 44"	Side borders: Cut 2.	16.3 cm x 111.2 cm
3" x 286"	Binding	7.2 cm x 733 cm

U.S.	Floral for border	Metric
6½" x 14½"	Cut 2.	16.3 cm x 37.2 cm

U.S.	Dark solid for border	Metric
6½" x 29"	Cut 2.	16.3 cm x 74.4 cm

BACKGROUND ASSEMBLY

1. Use a design wall to arrange the background squares in a manner that pleases you.

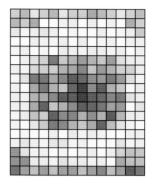

Arranging background squares

2. Sew 14 squares together to make 1 row. Make 18 rows. Press the seams of alternate rows in opposite directions.

3. Sew the rows together and press the top carefully.

APPLIQUÉ

1. Sew 2 petals, right sides together, using a scant ¼" (0.6 cm) seam allowance. Sew completely around the edges. Clip the curves.

2. Make a small slit in 1 side of the petal, taking care not to clip through to the other side of the petal.

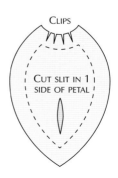

CLIPS

CUT SLIT IN 1 SIDE OF PETAL

Sewing petals
Make 205

3. Turn the petal right side out by pulling it gently through the slit. Carefully push out the corners and curves with a stiletto tool. Press. Make 205 petals.

4. Note that the flowers, leaves, and buds are scattered randomly across the surface of the quilt. In this case, a design wall is ideal for creating the most pleasing arrangement. Machine quilters note: For finishing ease consider quilting the surface before adding the 3-D elements.

5. Create a cherry blossom by arranging and pinning 5 petals to the pieced background. Leaving the outer edges of the petals unstitched, hand stitch the petals along their inner edges to the pieced background. Embroider a straight line through the center of each petal, finishing with a French knot at the outer end of each line. Make 40 blossoms and stitch the 5 remaining petals randomly on the quilt top.

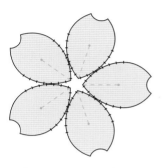

Petal arrangement and stitching
Make 40 Cherry Blossoms

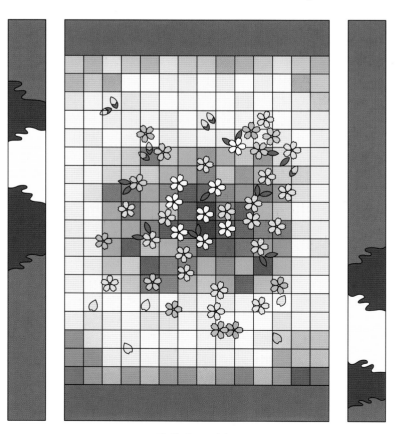

Quilt Assembly

6. Stitch the leaves and petals to the quilt top using your preferred appliqué technique, turning under the raw edges.

7. Sew 2 buds, right sides together, along the sides. Leave the base of the bud unstitched. Turn the bud right side out through the base. Carefully push the pointed tip and sides into place with a stiletto. Press. Pin a calyx in place to cover the lower half of each bud. Turning under the raw edges, appliqué the calyx into place over the bud and to the quilt top.

Borders

1. Sew the top and bottom geometric border strips to the quilt top. Press the seams toward the borders.

2. For the pieced side borders cut a solid border strip into 2 unequal lengths as shown.

Solid border strip

3. Draw a wavy line over each end of a floral border strip.

4. Cut the floral border strip along the drawn wavy lines, leaving a turn-under allowance. Appliqué each end of the floral border strip to the solid border strip cut in Step 2.

5. Cut each side geometric border strip into 2 unequal lengths.

6. Draw a wavy line over each end of the solid border strip. Cut along the drawn wavy lines, leaving a turn-under allowance. Appliqué each end of the solid border strip to the geometric border strip cut in Step 5.

7. Repeat the steps to create the other side border. Then press the completed side borders and trim to measure 75½" (193.4 cm).

8. Sew the side borders to the quilt top. Press the seams toward the borders.

Finishing

1. Layer and baste the backing, batting, and quilt top.

2. Quilt the center field of the top in a random design of blossoms, scallops, and leaves. Quilt the geometric border in a diagonal grid. Quilt the pieced borders in curvy lines to echo the appliquéd ends of these borders.

Blossom petal

Add seam allowance
Make 410

Leaf

Add turn-under allowance
Make 15

Calyx

Add turn-under allowance
Make 7

Leave open

Blossom bud

Add seam allowance
Make 14

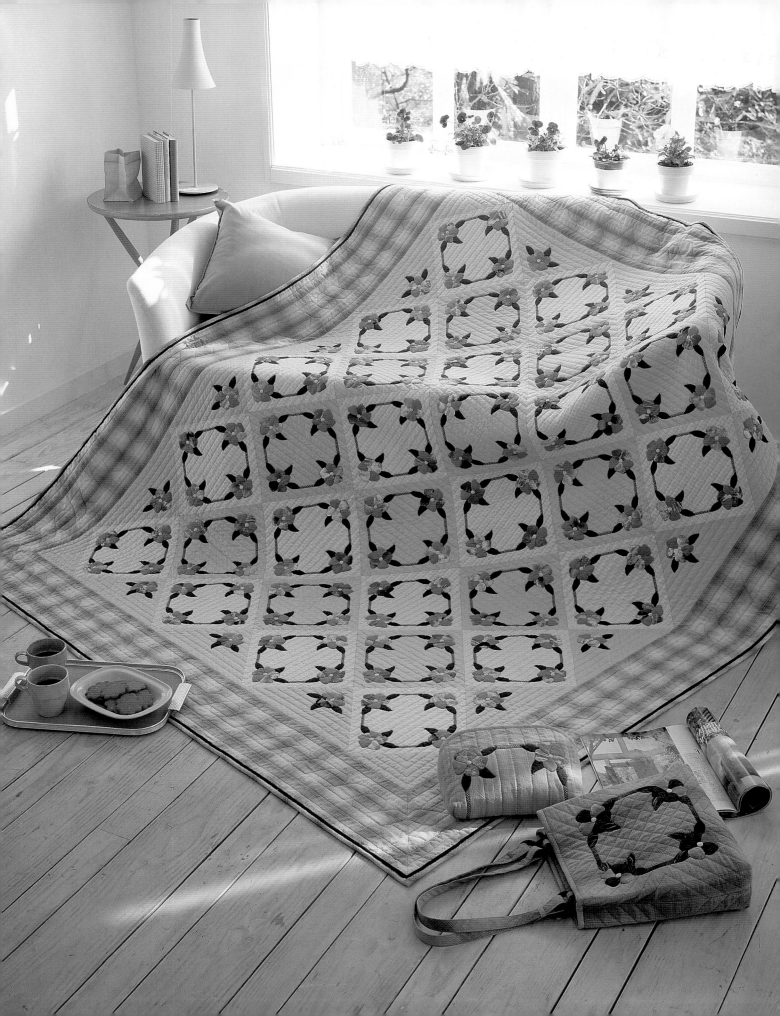

Wreath of Violets Quilt

Sometimes the simplest designs are the nicest, such as these pretty violet wreaths turned on point and set within a plaid border. This is a great project for appliqué fans of all skill levels. Use the basic block to create an accent pillow for a chic touch to a bedding ensemble.

FABRIC REQUIREMENTS

U.S.		Metric
2½ yards	Background A for appliqué blocks	2.3 meters
2½ yards	Background B for appliqué blocks	2.3 meters
½ yard	Medium green for appliqué stems	40 cm
1½ yards	Dark green for leaves and flanged border	1.3 meters
2 yards	Assorted lavenders for petals	1.9 meters
¼ yard	Yellow for blossom centers	20 cm
3¼ yards	Plaid for border and binding	3 meters
5 yards	Backing	4.5 meters
76" x 90"	Batting	200 cm x 225 cm

Optional: Bias tape maker, ¼" (0.6 cm)

CUTTING

U.S.	Background A	Metric
12" x 12"	Appliqué blocks: Cut 12 squares. *Note: These blocks are cut slightly larger than necessary and will be trimmed after completing the appliqué.*	30 cm x 30 cm
15⅜" x 15⅜"	Side-setting triangles: Cut 4 squares, then cut each square diagonally into quarters. You will have 2 extra triangles.	38.6 cm x 38.6 cm
8" x 8"	Corner triangles: Cut 2 squares, then cut each square diagonally into halves.	19.9 cm x 19.9 cm

Made by Chizuko Ono, Photo by Norio Ando
Finished Size: 71¼" x 85⅜" (179.6 cm x 215 cm)
Finished Block Size: 10" x 10" (25 cm x 25 cm)
Techniques: Appliqué

U.S.	Background B	Metric
12" x 12"	Appliqué blocks: Cut 20 squares. *Note: These blocks are cut slightly larger than necessary and will be trimmed after completing the appliqué.*	30 cm x 30 cm

U.S.	Medium green	Metric
16" x 16"	Stems: Cut 1 square. Refer to General Instructions on page 62 for making continuous bias strips. Cut ½" (1.2 cm) wide bias strips.	37 cm x 37 cm

U.S.	Dark green	Metric
◗	Leaves: Cut 426.	◗
1¼" x 71¼"	Top and bottom flanged borders: Cut 2.	2.2 cm x 179.6 cm
1¼" x 85⅜"	Side flanged borders: Cut 2.	2.2 cm x 215 cm

U.S.	Assorted lavenders	Metric
◠	Petals: Cut 710.	◠

U.S.	Yellow	Metric
○	Blossom centers: Cut 142.	○

U.S.	Plaid	Metric
7⅝" x 71¼"	Top and bottom borders: Cut 2.	19.6 cm x 179.6 cm
7⅝" x 85⅜"	Side borders: Cut 2.	19.6 cm x 215 cm
27" x 27"	Binding: Cut 1 square. Refer to General Instructions on page 62 for making continuous bias strips. Cut 2" (5 cm) strips.	70 cm x 70 cm

BLOCK AND QUILT ASSEMBLY

1. Cut the continuous bias strip of medium green stem fabric into 3½" (8.8 cm) lengths. You will need 128 stems. Option: Use a ¼" (0.6 cm) bias tape maker to turn under the raw edges of the bias strip before cutting the 3½" (8.8 cm) lengths.

2. Each appliqué block requires 4 stems, 12 leaves, 20 petals, and 4 blossom centers. Each side setting triangle requires 3 leaves, 5 petals and 1 blossom center.

3. Using the appliqué method of your choice, stitch 4 stems and 4 blossoms with leaves to each background square. Press carefully. Trim each completed block to measure 10½" x 10½" (26.2 cm x 26.2 cm). Make 32 blocks.

4. Appliqué a blossom with 3 leaves to each of the 14 side setting triangles. Press carefully.

5. Referring to the Quilt Assembly diagram, arrange the appliqué blocks into rows, alternating blocks with Background A and blocks with Background B. Add the corner and side setting triangles as shown. Press as shown.

BORDERS

1. Refer to General Instructions on page 61 for applying mitered borders.

2. Press the flanged border strips in half lengthwise. Sew to the outside edge of the border.

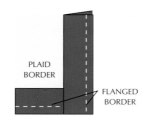

Flanged border

FINISHING

1. Layer and baste the backing, batting, and quilt top.

2. Quilt parallel lines ¾" (1.8 cm) apart through each appliqué block. The Background A lines run parallel to the side borders. The Background B lines run parallel to the top and bottom borders. Continue the pattern of the quilting lines into the corner and side setting triangles.

3. Center a quilted cable design in the borders and then run parallel lines of quilting the length of the border in the remaining space.

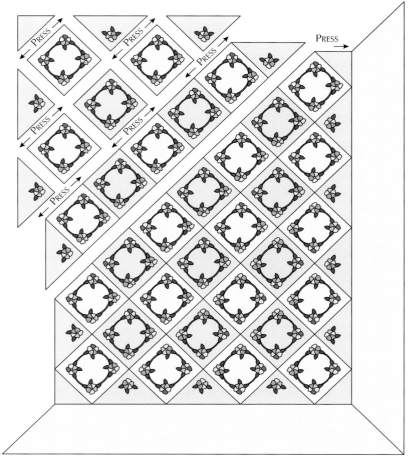

Quilt Assembly

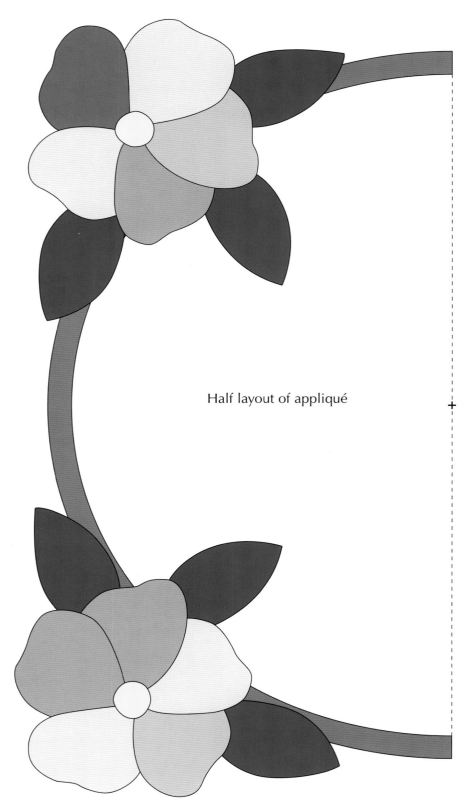

Half layout of appliqué

Leaf

Add turn-under allowance
Make 426

Petal

Add turn-under allowance
Make 710

Blossom center

Add turn-under allowance
Make 142

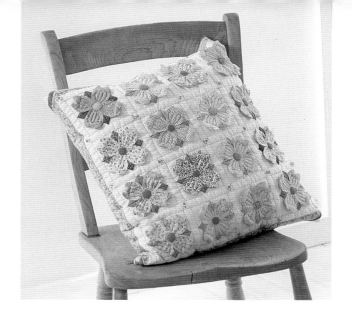

Spruce up your décor with a party dress for a pillow. This novel pillow cover with 3-D blossoms can transform the drabbest of pillows into a party-ready Cinderella.

Blossom Pillow

FABRIC REQUIREMENTS

U.S.		Metric
½ yard	Cream for background and sashing	45 cm
⅜ yard	Green for leaves	30 cm
½ yard total	Assorted small floral prints for petals	45 cm total
⅜ yard	Red for blossom centers, binding, and loops	30 cm
⅛ yard	Floral print for posts	5 cm
½ yard	Green print for corners	40 cm
⅞ yard	Lining (will not be seen)	75 cm
28" x 28"	Batting	70 cm x 70 cm
18" x 18"	Pillow form	45 cm x 45 cm
¾"	Button	2 cm

Note: *Fussy cuts to frame floral images for posts may require more yardage.*

Made by Shizuko Nakayama, Photo by Masaki Yamamoto
Finished Size: (open): 25" x 25" (60.2 cm x 60.2 cm)
Finished Block Size: 3½" x 3½" (8.5 cm x 8.5 cm)
Techniques: Piecing/3-D appliqué

CUTTING

U.S.	Cream	Metric
2⅝" x 2⅝"	Blossom background: Cut 32 squares.	6.5 cm x 6.5 cm
1⅛" x 4"	Sashing: Cut 40.	2.7 cm x 9.7 cm

U.S.	Green	Metric
2⅝" x 2⅝"	Leaves: Cut 32 squares.	6.5 cm x 6.5 cm

U.S.	Small floral prints	Metric
⬠	Petals: Cut 64.	⬠

U.S.	Red	Metric
◯	Blossom center: Cut 16.	◯
2¼" x 112"	Binding: Cut 1.	4.8 cm x 270 cm
1" x 3"	Loops: Cut 3.	2.5 cm x 7.5 cm

U.S.	Floral print	Metric
1⅛" x 1⅛"	Posts: Cut 25 squares.	2.7 cm x 2.7 cm

U.S.	Green print	Metric
13" x 13"	Corners: Cut 2 squares.	31.5 cm x 31.5 cm

U.S.	Lining	Metric
28" x 28"	Cut 1.	70 cm x 70 cm

U.S.	Batting	Metric
⬠	Petal stuffing: Cut 64.	⬠
◯	Blossom center stuffing: Cut 16.	◯
28" x 28"	Cut 1.	70 cm x 70 cm

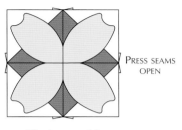

BACKGROUND ASSEMBLY

1. Draw a line diagonally across the wrong side of each background square. Match a background square to a leaf square, right sides together. Sew ¼" (0.6 cm) from both sides of the drawn line. Cut apart the square along the drawn line.

*Sewing a petal background
Make 32*

2. Press the seam toward the leaf square. Make 64 half-square triangle units with the remaining background and leaf squares.

PETAL ASSEMBLY

1. Place 2 petals right sides together. Sew along the 3 curved sides, leaving the 2 straight sides unsewn. Clip the top curve and the corners.

*Sewing a petal
Make 64*

2. Turn the petal right side out. Place a batting petal inside the sewn petal. Make sure that the batting petal fills out the top, curved end of the petal. Note that the batting should not reach the straight, unsewn ends of the petal. Baste closed the straight edges of the petal. Quilt a petal shape on the petal.

Stuffing and quilting a petal

BLOSSOM ASSEMBLY

1. Line up and pin the straight sides of the petal with the leaf corner of the half-square triangle unit. Baste.

*Basting a petal to a
background square*

2. Right sides together, sew 2 petal units. Press the seam open. Make 32 two-petal units. Pin and sew each 2-petal unit to another 2-petal unit to make a blossom. Press the seam open.

PRESS SEAMS
OPEN

*Block assembly
Make 16*

3. Hand stitch a basting line along the outer edge of a blossom center and draw up slightly. Place a piece of blossom center batting within the slightly cupped blossom center. Draw up the basted edge and secure.

BATTING

*Creating a blossom center
Make 16*

4. Pin and stitch the blossom center to the center of the blossom.

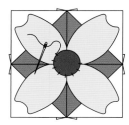

Stitching a center to a blossom

PILLOW ASSEMBLY

1. Alternately sew 4 blossom units to 5 sashing strips. Press the seams toward the sashing. Make 4 rows.

2. Alternately sew 4 sashing strips to 5 floral posts. Press the seams toward the sashing. Make 5 rows.

3. Alternately sew the 4 blossom rows to the 5 sashing/post rows. Press the seams toward the sashing/post rows.

4. Sew 2 corner triangles to opposite sides of the pillow top. Press the seams toward the corner triangles. Add the remaining corner triangles. Press the seams toward the corner triangles.

Adding corner triangles

FINISHING

1. Layer and baste the pillow top with the batting and lining. Quilt in the ditch along the sashing and posts. Quilt as desired in the corner triangles.

2. Trim and square up the corners of the pillow cover to measure 25" x 25" (60.2 cm x 60.2 cm).

3. Sew the loop right sides together with a scant ¼" (0.6 cm) seam allowance and turn to the right side.

Sewing corner loops
Make 3

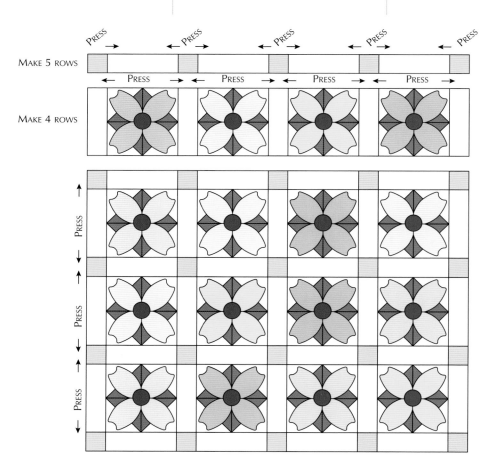

Assembling the blossom blocks, sashing, and posts

4. Bind the raw edges of the pillow top using your preferred method, inserting a folded loop into 3 of the corners. Stitch a button to the fourth corner.

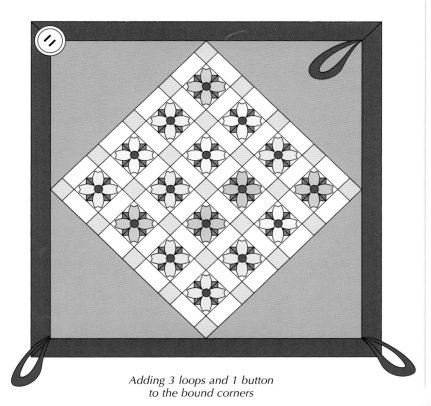

*Adding 3 loops and 1 button
to the bound corners*

5. Place a pillow form on the center of the wrong side of the blossom pillow top. Fold the corner with the button to the center of the pillow. Then fold each of the other 3 corners to the center, slipping each loop over the button.

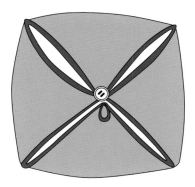

Closing the loops over the pillow form

Blossom center

Do not add seam allowance
Cut 16

Straight of grain

Petal

Do not add seam allowance
Cut 64

Blossom center stuffing

Cut 16

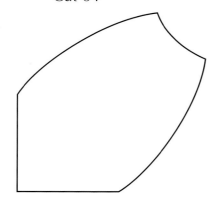

Petal stuffing

Cut 64

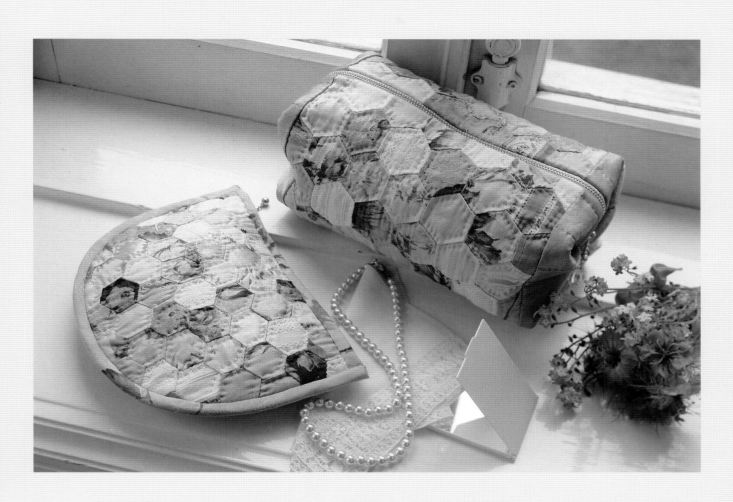

Hexagon Cosmetic Bags

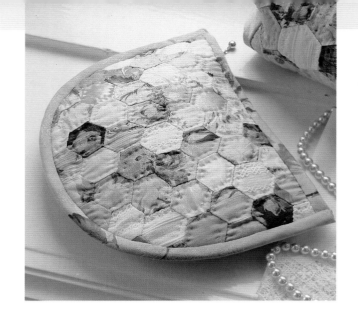

Simple and pretty, this cosmetic bag is a wonderful addition to any woman's personal carryalls. Note the two different color ways featured in the collection of hexagon accessories.

Hexagon Cosmetic Bag

FABRIC REQUIREMENTS

U.S.		Metric
¼ yard, total	Assorted floral scraps in pink, brown, and ecru	20 cm, total
¼ yard	Brown floral	20 cm
¼ yard	Lining	20 cm
14" x 10"	Batting	35 cm x 25 cm
9"	Zipper	23 cm
	Paper or plastic hexagon templates	

CUTTING

U.S.	Assorted floral scraps	Metric
2" x 2"	Hexagons: Cut 52 squares.	5 cm x 5 cm

U.S.	Brown floral	Metric
7" x 9¼"	Back: Cut 1.	18 cm x 24 cm
1¾" x 40"	Binding: Cut 1.	4.5 cm x 100 cm

Made by Naoko Hashimoto, Photo by Norio Ando
Finished Size: 6¾" x 9⅛" (17 cm x 22.8 cm)
Techniques: Hand and machine piecing/English paper piecing

U.S.	Lining	Metric
7" x 9¼"	Cut 2.	18 cm x 24 cm

U.S.	Batting	Metric
9" x 11"	Cut 2.	22 cm x 27 cm

PROJECT ASSEMBLY

1. Refer to General Instructions on page 61 to make 52 hexagons. Assemble the hexagons into rows and then stitch the rows together.

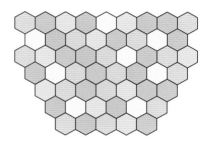

Hexagon layout

2. Front side: Layer the hexagon unit with 1 piece of batting and 1 lining. Quilt ⅛" (0.3 cm) inside of each hexagon.

3. Back side: Layer the back, batting, and lining. Quilt parallel lines 1" (2.5 cm) apart.

4. Trace the bag pattern onto each of the quilted units. Cut along the drawn lines.

Tracing the pattern

5. Fold the binding in half lengthwise, wrong sides together. Use a ¼" (0.6 cm) seam allowance to sew the binding to the straight edge of the outside of the quilted pieces.

Sewing the binding to the outside

6. Fold the binding over to the lining side of the quilted pieces and hand stitch in place.

Stitching the binding to the lining side

7. Hand stitch the zipper to the lining side of each quilted unit. Be sure that the zipper is wrong side up as you sew it in place.

Stitching the zipper

8. With the lining sides facing and using a ¼" (0.6 cm) seam allowance, sew the binding to the curved edge of both sides of the cosmetic bag. Fold the short raw ends of the binding to the inside, then hand stitch the binding to the other side of the cosmetic bag.

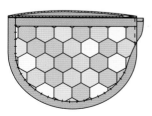

Binding the cosmetic bag

Hexagon

Make 52

Cosmetic bag

Make 2

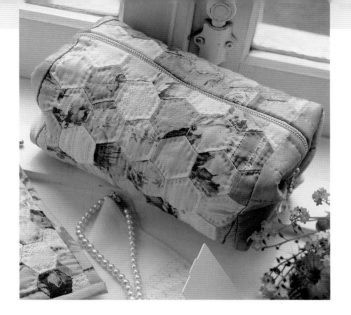

Pretty carryalls are wonderful gifts for honeymoons or romantic getaways. Here a patchwork of floral hexagons adorns a charming travel kit for the stylish traveler.

Hexagon Travel Kit

FABRIC REQUIREMENTS

U.S.		Metric
¾ yard, total	Assorted floral prints	60 cm, total
¼ yard	Moss green for borders	20 cm
½ yard	Light print for lining and binding	40 cm
16" x 21"	Batting	40 cm x 53 cm
15"	Zipper	38 cm

CUTTING

U.S.	Assorted floral prints	Metric
3" x 3"	Squares: Cut 91.	7.5 cm x 7.5 cm

U.S.	Moss green	Metric
3½" x 20½"	Side borders: Cut 2.	8.8 cm x 51.3 cm

U.S.	Light print	Metric
15½" x 20½"	Lining: Cut 1.	38.8 cm x 51.3 cm
2¼" x 6"	Binding: Cut 2.	5.6 cm x 15 cm

Made by Naoko Hashimoto, Photo by Norio Ando
Finished Size: 10½" x 5" x 5" (26.3 cm x 12.5 cm x 12.5 cm)
Techniques: Hand and machine stitching/English paper piecing

PROJECT ASSEMBLY

1. Refer to General Instructions on page 61 to make 91 hexagons.

2. Assemble the hexagons into a pieced unit and trim to measure 9½" x 20½" (21.2 cm x 51.3 cm).

3. Sew a border to each of the long sides of the pieced hexagon unit. Press the seams toward the borders.

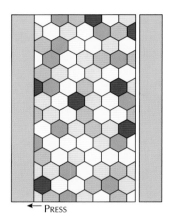

← PRESS

Adding side borders

4. Layer the pieced unit with the batting and the lining. Quilt ¼" (0.6 cm) inside of each hexagon. In the borders, quilt parallel lines 1¼" (3 cm) apart, extending from the hexagons to the outside of the quilted unit.

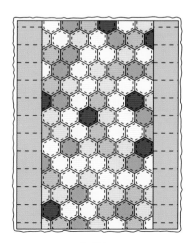

Quilting

5. Fold the short sides of the quilted unit ¼" (0.6 cm) to the lining side. Baste.

] ¼"
(0.6 CM)

LINING SIDE

Turning edge to inside

6. Hand stitch the zipper to the folded short sides of the quilted unit, covering the raw edges. Be sure the wrong side of the zipper is facing you as you stitch it in place to the lining side of the travel kit.

7. Close the zipper. Fold the travel kit in half right sides together and place a pin at the center point.

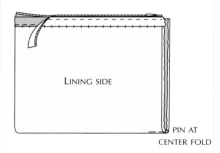

LINING SIDE

PIN AT
CENTER FOLD

8. Fold the travel kit again by bringing the center pin up to meet the zipper. Place a pin at each side fold.

PIN

PIN

PIN

Second fold

9. Pleat the ends of the travel kit by pushing the side pins in to meet the center pin. Pin and sew in place with a ½" (1.2 cm) seam allowance, making sure to open the zipper before sewing the seams.

Pleat ends and pin

10. Use a ½" (1.2 cm) seam allowance to sew the 6" (15 cm) length of binding strip over the seam. Fold the binding to the other side of the seam to cover the raw ends and hand stitch in place over the machine stitching. Tuck in the raw ends of the binding.

TUCK IN END SEW ½" (1.2 CM) SEAM

Finishing the travel kit

11. Turn the travel kit right side out. Bon voyage!

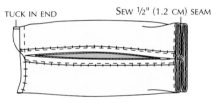

Make 91

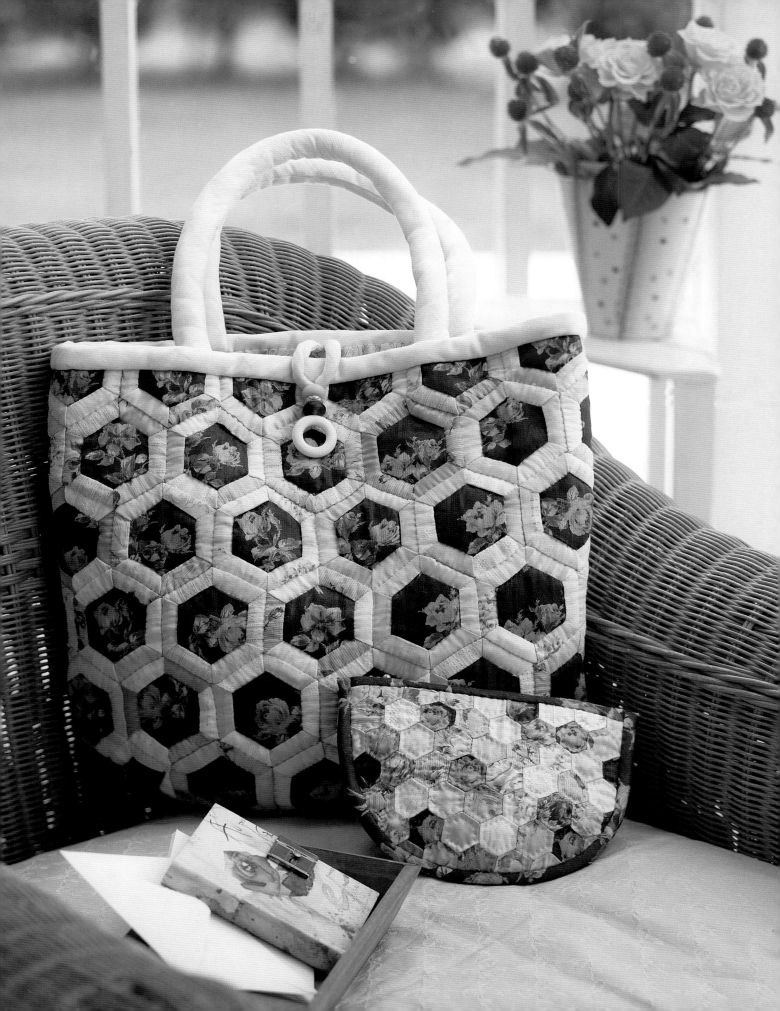

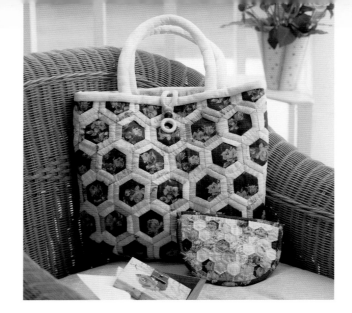

Here's an interesting variation using framed and pre-quilted hexagons to create a charming purse.

Hexagon Purse

FABRIC REQUIREMENTS

U.S.		Metric
1⅛ yard	Brown floral print for hexagon centers	1 meter
2¾ yard	Textured print for hexagon frames	2.4 meters
⅝ yard	Light print for lining and pocket	50 cm
⅜ yard	Cream solid or tone-on-tone for loop, handles, and binding	35 cm
40" x 40"	Batting for hexagon centers	1 meter x 1 meter
½ x ¼ yard	Cording for loop	2 cm x 20 cm
1¼ x 1⅜ yard	Cording for handles	3.5 cm x 120 cm
	Template plastic	
	Bodkin	
	Beads	
	Silk cord to fit doubled through your chosen beads	

Made by Naoko Hashimoto, Photo by Norio Ando
Finished Size: 18¾" wide x 17" high (46.8 cm wide x 42.8 cm high)
Special techniques: Hand and machine stitching/Beading

CUTTING

U.S.	Template plastic	Metric
⬡	Cut 1 template for hexagon frames.	⬡
⬡	Cut 1 template for batting and hexagon center.	⬡

U.S.	Textured print	Metric
⬡	Hexagon frames: Cut 86.	⬡

U.S.	Brown floral	Metric
⬡	Hexagon centers: Cut 86.	⬡

U.S.	Batting	Metric
⬡	Cut 86.	⬡

U.S.	Light print	Metric
20" x 20"	Lining: Cut 2.	50 cm x 50 cm
10" x 10½"	Pocket: Cut 1.	25 cm x 26.5 cm

U.S.	Cream	Metric
2" x 7"	Loop: Cut 1.	5 cm x 17 cm
3¼" x 23"	Handles: Cut 2.	8 cm x 58 cm
5½" x 40"	Binding: Cut 1.	14 cm x 100 cm

BLOCK ASSEMBLY

1. Center a batting hexagon on the wrong side of a hexagon frame. Place a floral hexagon on top of the batting hexagon.

Place floral hexagon on batting

2. Fold 1 straight edge of the hexagon frame to meet the edge of the floral hexagon and batting. Fold the hexagon frame a second time to overlap the raw edge of the floral hexagon. Stitch in place.

Stitch fold over raw edge of floral hexagon

3. Continue to fold and stitch the hexagon frame around the remaining sides of the floral hexagon. Tuck in the corners to make sharp pleats and stitch in place. Make 86 framed hexagons.

Stitched sides of hexagon frame overlapping floral center
Make 86

4. Right sides together, match 2 hexagons and hand stitch along 1 matching side. Continue matching and sewing hexagons to create the unit pictured. Each unit contains 43 hexagons. Repeat the process for the second hexagon unit. These units will become the front and back sides of the purse.

Stitching hexagons together

Assembly of hexagon unit
Make 2

MAKING THE PURSE

1. Enlarge the pattern on page 57 and trace onto each hexagon unit. Mark dart placement.

2. To stabilize the hexagon unit, use a small machine stitch and sew just inside of the drawn line. Then cut out each hexagon unit along the drawn line.

3. Sew the darts and finger-press flat. From the right side of the unit, sew through the center of the dart.

This step will keep the dart flat and evenly distribute its bulk.

Sew dart

Sew through center of dart

4. Right sides together, use a ½" (1.2 cm) seam allowance to stitch together the hexagon units. Trim the seam to reduce bulk.

MAKING THE POCKET

Fold and press the sides and bottom of the pocket ½" (1.2 cm) toward the wrong side of the pocket. Fold the top of the pocket down ½" (1.2 cm) toward the wrong side. Fold the top of the pocket again 1" (2.5 cm) toward the wrong side. Topstitch along the folded edge of the pocket top.

Pocket

MAKING THE LINING

1. Place the purse pattern over the lining and trace. Mark dart placement. Cut out the lining along the drawn line. Make 2.

2. Sew the darts and press toward the bottom of the purse.

3. Center the pocket 4 ½" (11 cm) from the top edge of 1 lining. Sew the pocket to the lining along the sides and bottom of the pocket.

4. Place the lining pieces right sides together and sew with a ½" (1.2 cm) seam allowance.

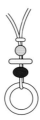

Linings sewn with right sides together

MAKING THE LOOP AND HANDLES

Sew the loop and handle pieces right sides together along the long edges. Turn each piece right side out. Use a bodkin or similar tool to pull the narrow cording through the loop and the wider cording through the handles.

Making handles and loops

MAKING THE BEADED CLOSURE

Arrange the beads as desired. Thread the silk cord through the beads and over the ring. String the silk cord back through the beads, pull snug, and tie a knot.

Stringing beads for closure

PURSE ASSEMBLY

1. Wrong sides together, place the purse inside of the lining. Pin the purse to the lining along the top edge. Fold the loop and pin it to the center of one side of the purse as shown. Center and pin the handles to the sides of the lining, spacing the ends of the handles 7" (17 cm) apart.

Baste along the top edges of the purse and the lining, catching the ends of the loop and handles in your stitching. Turn the purse right side out. Pin the beaded closure to the outside of the purse in a position that is exactly opposite to the loop.

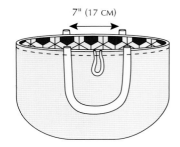

Baste along top edge

2. Wrong sides together, fold the binding strip in half. Pin the binding strip to the top edge of the purse. Cut the binding ¾" (1.9 cm) longer than necessary to encircle the top edge of the purse. With a ⅜" (0.9 cm) seam allowance, sew the short ends of the binding together and press open. Tuck the handles and the loop inside of the purse. With a ⅞" (2.3 cm) seam allowance, sew the binding to the top edge of the purse. Turn the binding to the inside of the purse and hand stitch in place.

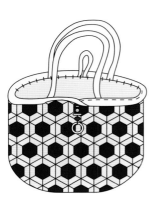

Sewing binding to bag

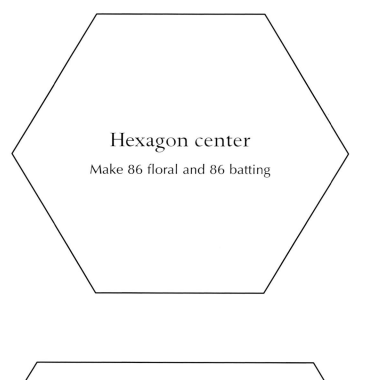

Hexagon center

Make 86 floral and 86 batting

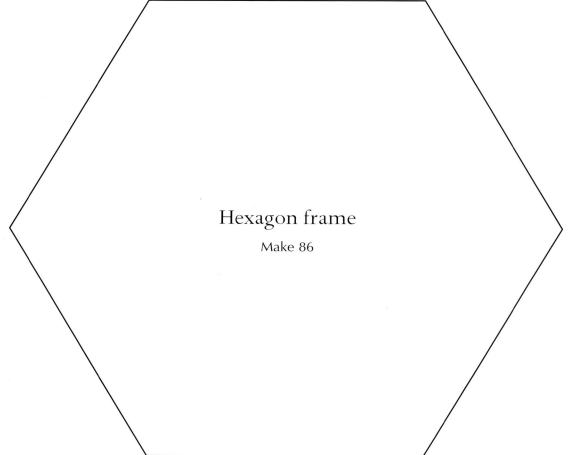

Hexagon frame

Make 86

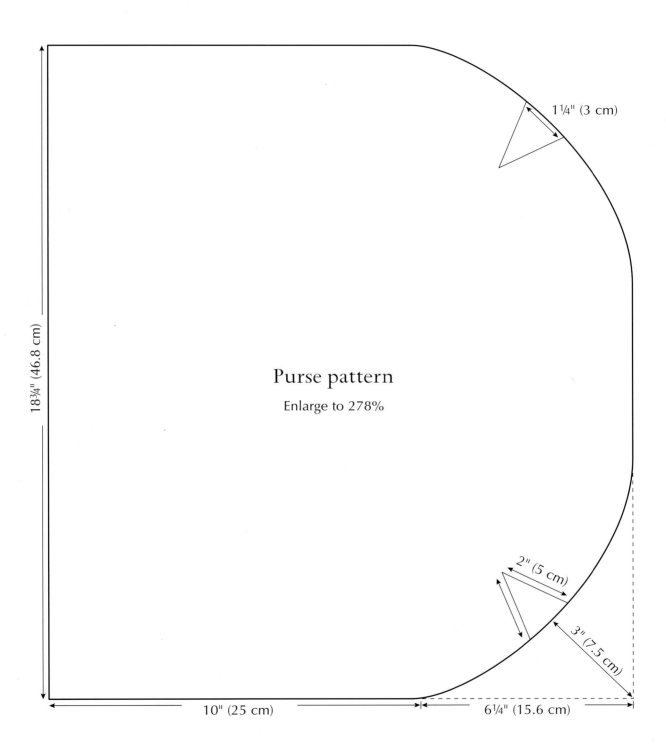

Purse pattern

Enlarge to 278%

1¼" (3 cm)

18¾" (46.8 cm)

2" (5 cm)

3" (7.5 cm)

10" (25 cm)

6¼" (15.6 cm)

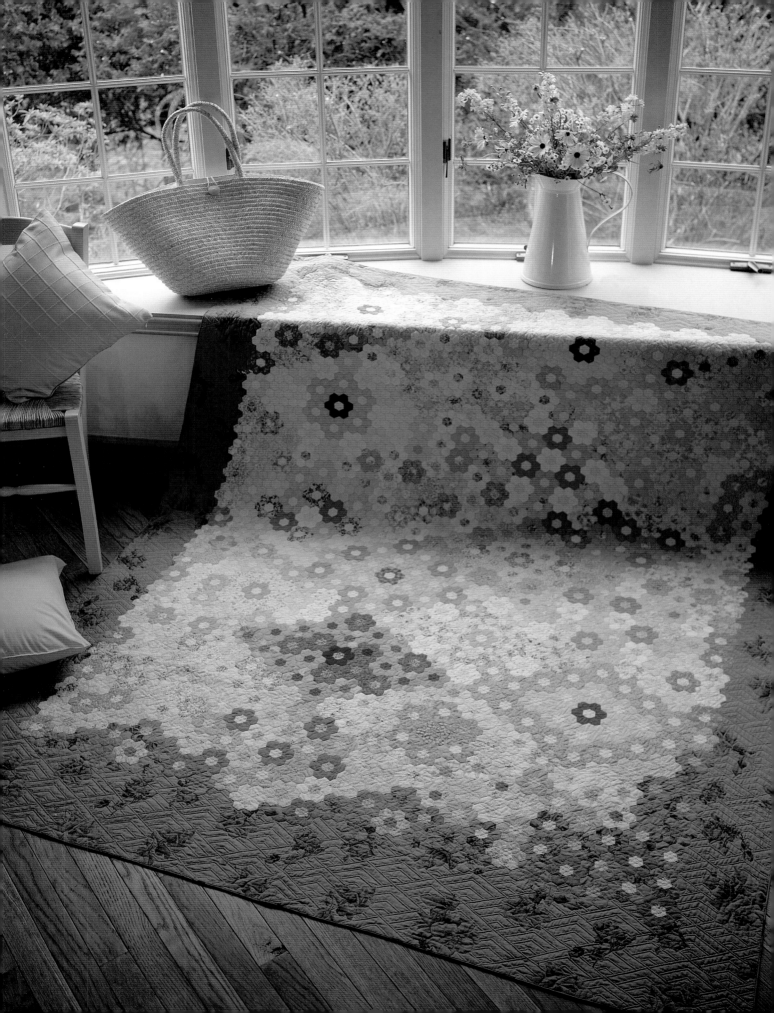

Hexagon Garden Quilt

This quilt exemplifies Bokashi, the Japanese method of blending colors. Note the subtle progression of color changes with rich earth tones hugging the bottom, floral shades and garden greens in the middle, and sky blues at the top. Note: Use of a design wall is highly recommended.

FABRIC REQUIREMENTS

U.S.		Metric
6½ yards	Assorted small prints for hexagon petals and flower centers	5.9 meters
4 yards	Large floral for borders and binding	3.7 meters
5 yards	Backing	4.5 meters
73" x 88"	Batting	180 cm x 220 cm
	Paper or plastic hexagon templates	

CUTTING

U.S.	Flower centers	Metric
2" x 2"	Squares: Cut 324.	5 cm x 5 cm

U.S.	Flower petals	Metric
2" x 2"	Squares: Cut 6 per flower for a total of 1,944 petals.	5 cm x 5 cm

U.S.	Large floral	Metric
12" x 89"	Side borders: Cut 2.	30 cm x 222.5 cm
12" x 73"	Top and bottom borders: Cut 2.	30 cm x 182.5 cm
2½" x 320"	Binding	6.25 cm x 800 cm

Made by Tae Kitagawa, Photo by Norio Ando
Finished Size: 69" x 84" (172.5 cm x 210.3 cm)
Technique: Hand stitching/English paper piecing

HEXAGON FLOWER ASSEMBLY

Note: Each of the 324 hexagon flowers is made up of a center hexagon surrounded by 6 petal hexagons. The sides of the hexagon garden have straight edges, but the top and bottom edges are scalloped.

1. Refer to General Instructions on page 61 for creating your hexagons. Make 2,268 hexagons.

2. Right sides together, match a flower center hexagon to a flower petal hexagon. Working from the wrong side, whipstitch these 2 hexagons together along 1 side.

3. Without breaking your thread, continue stitching around the sides of the center with the remaining 5 petal hexagons.

Petals stitched to center hexagon

4. Remove the template (paper or plastic) from inside of the flower center. Fold the flower in half and, working from the wrong side, whipstitch the petals together.

Petals stitched to center hexagon

5. Stitch the hexagon flowers to each other in the same manner to make your garden. The hexagon template may be removed once it is surrounded by other hexagons.

BORDERS

1. Pin the side edge of the quilt top along the length of 1 side border, both right sides up. Check to be sure that the side edge of the garden overlaps the raw edge of the border by ½" (1.2 cm). Appliqué the edges of the hexagons to the side border, but leave the first and last few hexagons temporarily unstitched. Repeat with the other side border and then the top and bottom borders. Stitch the corners of the borders last, also securing the unstitched hexagons.

2. Trim the borders to an even 10" (25.5 cm) beyond the edges of the hexagon garden.

FINISHING

Layer and baste the quilt top, batting, and backing. Quilt the flowers with lines radiating from their centers through the petals. Quilt the borders with double lines of stacked diamonds.

Make 2,268

The hexagon projects may look challenging at first glance, but hexagons are quite easy to piece by hand. Here's a quick review of two template-based methods.

ENGLISH PAPER PIECING

This method uses pre-cut paper hexagon templates to construct uniformly sized hexagon units. Each hexagon project in this book has a hexagon template that can be used to cut your own paper templates, but quilt shops and on-line suppliers sell pre-cut paper templates in a wide variety of sizes. When projects call for hundreds, even thousands of hexagons, pre-cut templates are very appealing. A popular on-line source is www.cddesigns.com. They sell many different sizes of hexagons in packages ranging from 100 to 1500 hexagons. The paper hexagon templates are not reusable.

For this method you'll need a paper hexagon template and a square of fabric.

1. Pin a paper hexagon on the wrong side of a fabric square. Trim the fabric to a scant ⅜" (1 cm) seam allowance.

TRIM SCANT ⅜" (1 CM)

WRONG SIDE OF FABRIC

2. Fold 1 side of the fabric over the paper hexagon. Finger press fold.

3. Fold the fabric over the second side of the hexagon and finger press a sharp pleat at the corner of the hexagon. Take 2 small basting stitches through the pleat. Repeat for each side.

QUILT PATIS

An interesting and fun alternative is a product called Quilt Patis from Picking Up the Pieces. Again, the hexagons come in a range of sizes, but these hexagon templates are plastic and reusable. Follow the instructions included in the package.

> The Original Quilt Patis
> From Picking Up the Pieces
> 911 City Park Avenue
> Columbus, OH 43206
> (614) 443-9988

MITERED CORNER BORDERS

1. Measure the length of the quilt top and add 2 times the width of your border, plus 5" (12.5 cm). This is the length you need to cut or piece the side border strips.

2. Place pins at centers of both side borders and all 4 sides of the quilt top. From the center pin of the border strip, measure and mark with pins half the measured length of the quilt top. Pin the border strip to the quilt top, matching border pins to center pin and the ends of the quilt top. Stitch the strips to the sides of the quilt top. Stop and backstitch at the seam allowance line, ¼" (0.6 cm) in from the edge. The excess length will extend beyond each edge. Press seams toward border.

STOP STITCHING ¼" (0.6 CM) FROM EDGE

3. Determine the length needed for the top and bottom borders the same way, measuring the width of the quilt top through the center including each side border. Add 5" (12.5 cm) to this measurement. Cut or piece these border strips. From the center of each border strip, measure in both directions and mark half of the measured width of the quilt top. Again, pin, stitch up to the ¼" (0.6 cm)

seam line, and backstitch. The border strips extend beyond each end.

4. To create the miter, place the corner on the ironing board. Working with the quilt right side up, place 1 strip on top of the adjacent border.

5. Fold the top border strip under itself so that it meets the edge of the outer border and forms a 45° angle. Press and pin the fold in place.

FOLD UNDER AT A 45° ANGLE

6. Position a 90° angle triangle or ruler over the corner to check that the corner is flat and square. When everything is in place, press the fold firmly.

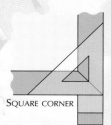

SQUARE CORNER

7. Fold the center section of the top diagonally from the corner, right sides together, and align the long edges of the border strips. On the wrong side, place pins near the pressed fold in the corner to secure the border strips.

8. Beginning at the inside corner, backstitch and stitch along the fold toward the outside point, being careful not to allow any stretching to occur. Backstitch at the end. Trim the excess border fabric to ¼" (0.6 cm) seam allowance. Press the seam open.

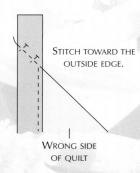

STITCH TOWARD THE OUTSIDE EDGE.

WRONG SIDE OF QUILT

CONTINUOUS BIAS STRIP

1. To make continuous bias strips cut a square in half diagonally and pin the 2 triangles together along the straight of grain.

2. Sew these triangles together as shown, using a ¼" (0.6 cm) seam allowance. Press the seam open.

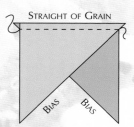

STRAIGHT OF GRAIN

BIAS BIAS

3. Using a ruler, mark the resulting parallelogram with lines spaced the width you need to cut your bias. Cut along the first line about 5" (12.5 cm).

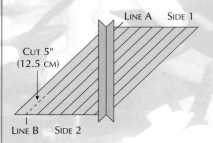

LINE A SIDE 1

CUT 5"
(12.5 CM)

LINE B SIDE 2

4. Join Side 1 and Side 2 to form a tube. Line A will line up with the raw edge at B. (This will allow the first line to be offset by one strip width.) Pin the raw ends together, making sure that the lines match. Sew with a ¼" (0.6 cm) seam allowance. Press seams open cut along marked lines.

Other Fine Books from C&T Publishing

Along the Garden Path: More Quilters and Their Gardens, Jean & Valori Wells

Appliqué 12 Easy Ways!: Charming Quilts, Giftable Projects, & Timeless Techniques, Elly Sienkiewicz

Art of Machine Piecing, The: How to Achieve Quality Workmanship Through a Colorful Journey, Sally Collins

Bouquet of Quilts, A: Garden-Inspired Projects for the Home, Edited by Jennifer Rounds & Cyndy Lyle Rymer

Butterflies & Blooms: Designs for Appliqué & Quilting, Carol Armstrong

Celebrate the Tradition with C&T Publishing: Over 70 Fabulous New Blocks, Tips & Stories from Quilting's Best, C&T Staff

Dresden Flower Garden: A New Twist on Two Quilt Classics, Blanche Young

Enchanted Views: Quilts Inspired by Wrought-Iron Designs, Dilys Fronks

Everything Flowers: Quilts from the Garden, Jean & Valori Wells

Flowering Favorites from Piece O' Cake Designs: Becky Goldsmith & Linda Jenkins

Four Seasons in Flannel: 23 Projects—Quilts & More, Jean Wells & Lawry Thorn

Floral Stitches: An Illustrated Guide to Floral Stitchery, Judith Baker Montano

Flower Pounding: Quilt Projects for All Ages, Ann Frischkorn & Amy Sandrin

Garden-Inspired Quilts: Design Journals for 12 Quilt Projects, Jean & Valori Wells

Luscious Landscapes: Simple Techniques for Dynamic Quilts, Joyce R. Becker

Paper Piecing Potpourri: Fun-Filled Projects for Every Quilter, From the Editors and Contributors of Quilter's Newsletter Magazine and Quiltmaker magazine

Paper Piecing with Alex Anderson: • Tips • Techniques • 6 Projects, Alex Anderson

Patchwork Persuasion: Fascinating Quilts from Traditional Designs, Joen Wolfrom

Patchwork Quilts Made Easy—Revised, 2nd Edition: 33 Quilt Favorites, Old & New, Jean Wells

Perfect Union of Patchwork & Appliqué, A, Darlene Christopherson

Pieced Flowers, Ruth B. McDowell Piecing: Expanding the Basics, Ruth B. McDowell

Plentiful Possibilities: A Timeless Treasury of 16 Terrific Quilts, Lynda Milligan & Nancy Smith

Q is for Quilt, Diana McClun & Laura Nownes

Quick-Strip Paper Piecing: For Blocks, Borders & Quilts, Peggy Martin

Quick Quilts for the Holidays: 11 Projects to Stamp, Stencil, and Sew, Trice Boerens

Quilted Garden, The: Design & Make Nature-Inspired Quilts, Jane Sassaman

Quilting Back to Front: Fun & Easy No-Mark Techniques, Larraine Scouler

Quilting with Carol Armstrong: • 30 Quilting Patterns • Appliqué Designs • 16 Projects, Carol Armstrong

Quilts for Guys: 15 Fun Projects For Your Favorite Fella, edited by Cyndy Lyle Rymer

Quilts, Quilts, and More Quilts!, Diana McClun & Laura Nownes

Ultimate Guide to Longarm Quilting, The: • How to Use Any Longarm Machine • Techniques, Patterns & Pantographs • Starting a Business • Hiring a Longarm Machine Quilter, Linda Taylor

Radiant New York Beauties: 14 Paper-Pieced Quilt Projects, Valori Wells

Reverse Appliqué with No Brakez, Jan Mullen

Ricky Tims' Convergence Quilts: Mysterious, Magical, Easy, and Fun, Ricky Tims

Rotary Cutting with Alex Anderson: Tips, Techniques, and Projects, Alex Anderson

Say It with Quilts, Diana McClun & Laura Nownes

Scrap Quilts: The Art of Making Do, Roberta Horton

Setting Solutions, Sharyn Craig

Shadow Redwork™ with Alex Anderson: 24 Designs to Mix and Match, Alex Anderson

Shoreline Quilts: 15 Glorious Get-Away Projects, compiled by Cyndy Rymer

Show Me How to Machine Quilt: A Fun, No-Mark Approach, Kathy Sandbach

Simple Fabric Folding for Christmas: 14 Festive Quilts & Projects, Liz Aneloski

Simply Stars: Quilts That Sparkle, Alex Anderson

Small Scale Quiltmaking: Precision, Proportion, and Detail, Sally Collins

Smashing Sets: Exciting Ways to Arrange Quilt Blocks, Margaret J. Miller

Soft-Edge Piecing: Add the Elegance of Appliqué to Traditional-Style Patchwork Design, Jinny Beyer

Special Delivery Quilts, Patrick Lose

Start Quilting with Alex Anderson, 2nd Edition: Six Projects for First-Time Quilters, Alex Anderson

Stitch 'n Flip Quilts: 14 Fantastic Projects, Valori Wells

Stripes In Quilts, Mary Mashuta

Strips 'n Curves: A New Spin on Strip Piecing, Louisa L. Smith

Sweet Dreams, Moon Baby: A Quilt to Make, A Story to Read, Elly Sienkiewicz

Thimbleberries Housewarming, A: 22 Projects for Quilters, Lynette Jensen

Totally Tubular Quilts: A New Strip-Piecing Technique, Rita Hutchens

Through the Garden Gate: Quilters and Their Gardens, Jean & Valori Wells

Tradition with a Twist: Variations on Your Favorite Quilts, Blanche Young & Dalene Young-Stone

Visual Dance, The: Creating Spectacular Quilts, Joen Wolfrom

Wild Birds: Designs for Appliqué & Quilting, Carol Armstrong

Wildflowers: Designs for Appliqué and Quilting, Carol Armstrong

Wine Country Quilts: A Bounty of Flavorful Projects for Any Palette, Cyndy Lyle Rymer & Jennifer Rounds

When Quilters Gather: 20 Patterns of Piecers at Play, Ruth McDowell

Workshop with Velda Newman, A: Adding Dimension to Your Quilts, Velda E. Newman

For more information,
write for a free catalog:
C&T Publishing, Inc.
P.O. Box 1456
Lafayette, CA 94549
(800) 284-1114
Email: ctinfo@ctpub.com
Website: www.ctpub.com

For quilting supplies:
Cotton Patch Mail Order
3405 Hall Lane, Dept.CTB
Lafayette, CA 94549
(800) 835-4418
(925) 283-7883
Email: quiltusa@yahoo.com
Website: www.quiltusa.com

Note: Fabrics used in the quilts shown may not be currently available since fabric manufacturers keep most fabrics in print for only a short time.

About the Editors

Jennifer Rounds is a professional quiltmaker and a freelance writer. She writes the "Feature Teacher" column for The Quilter magazine. Jennifer lives in Walnut Creek, California.

Catherine Comyns is a retired Registered Nurse who has made a second career out of her life-long passion for quiltmaking. Besides making award-winning quilts, she promotes the art and craft of quiltmaking in her work as a teacher, designer, and judge. Catherine lives in Pleasant Hill, California.

Index